An Adult Coloring Book

Cover Art
Samwise Didier

Editors
Rob Simpson and Cate Gary

Art Director
Roman Kenney

Senior Art Director, World of Warcraft
Chris Robinson

Senior Product Developer
Sean Wang

Project Manager
Brianne Loftis

Producer
Jeffrey Wong

Senior Manager, Global Licensing
Byron Parnell

Manufacturing Director
Anna Wan

Blizzard Director of Story and Creative Development
James Waugh

Illustrator
Mirco Tangherlini

Printing by
Tecnostampa - Pigini Group Printing Division - Loreto - Trevi

ISBN: 978-0-9897001-6-0
10 9 8 7 6 5 4 3 2 1
Printed in Italy

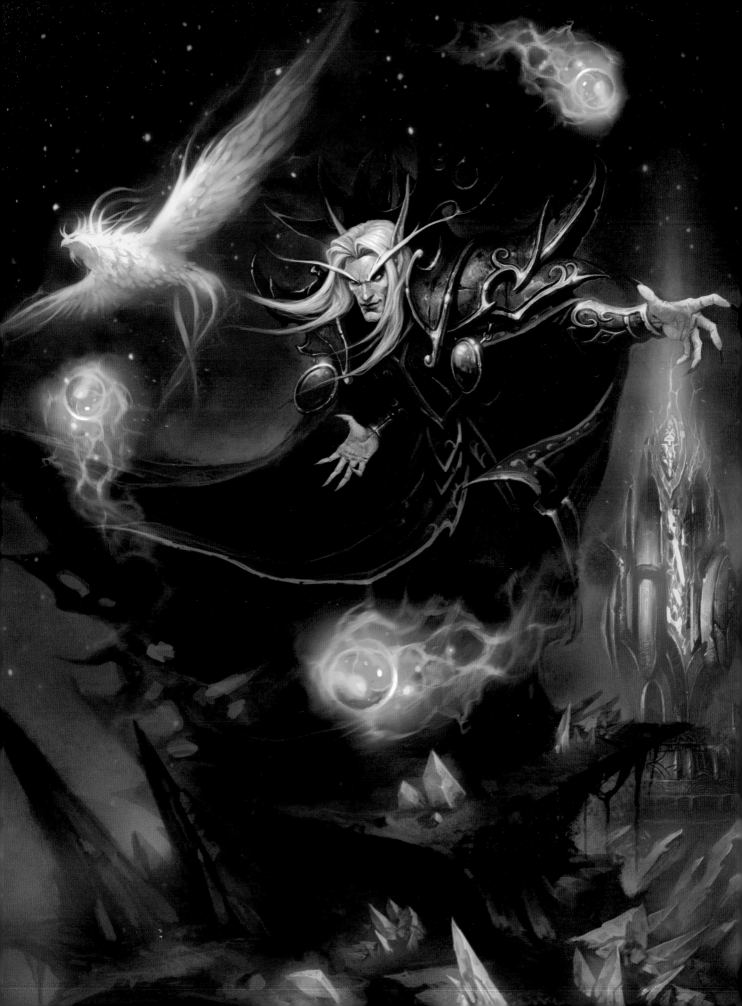

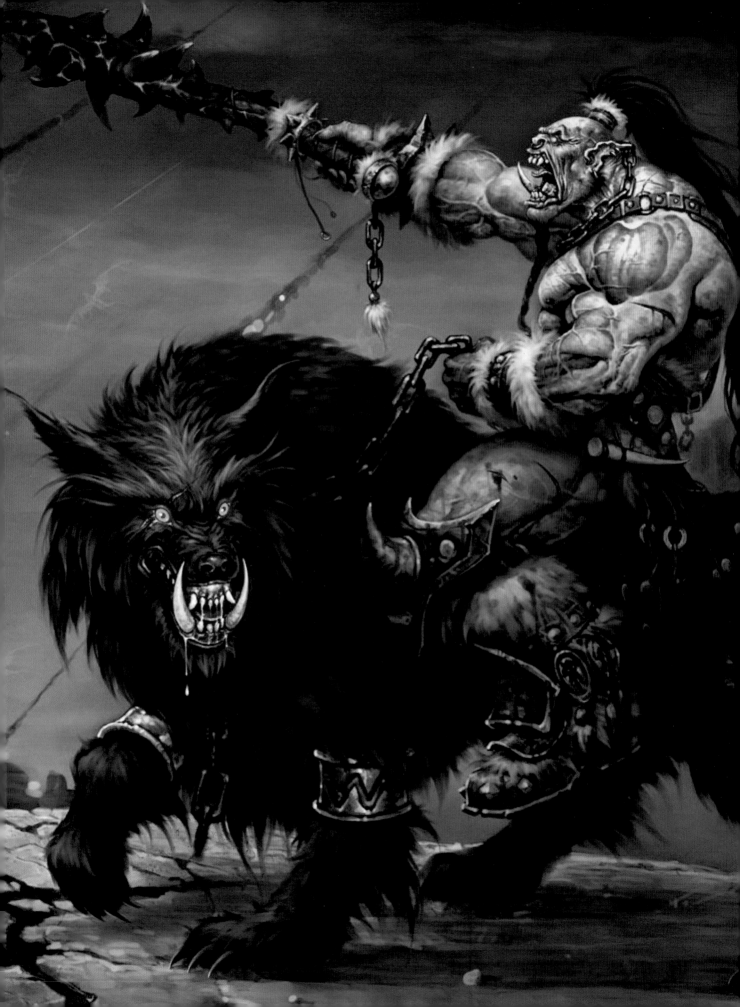

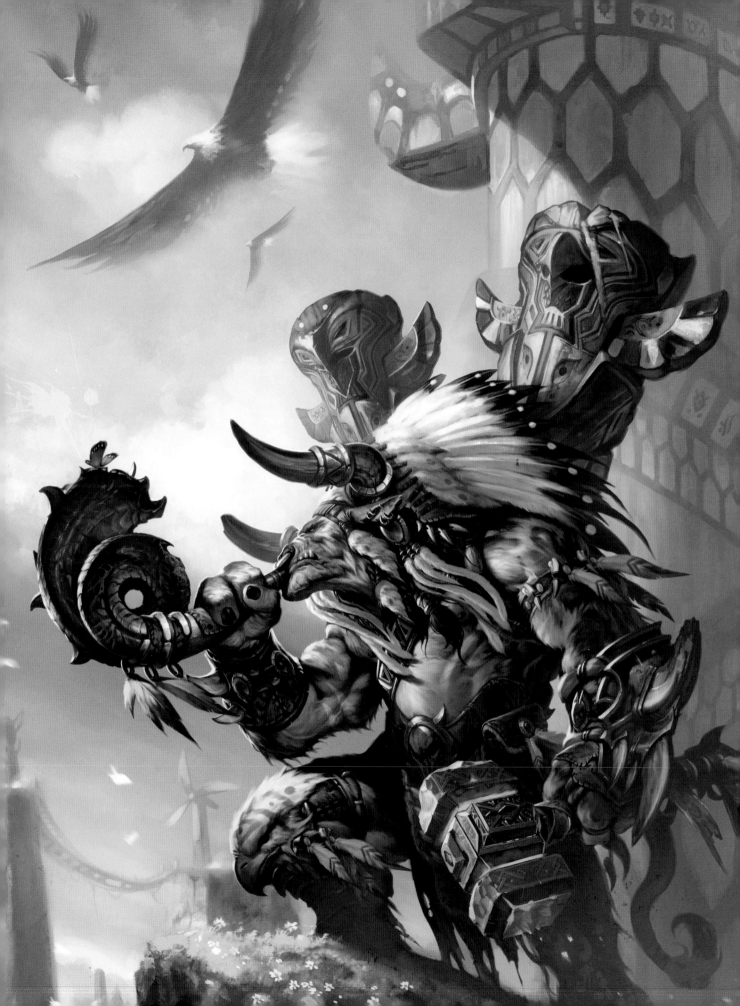

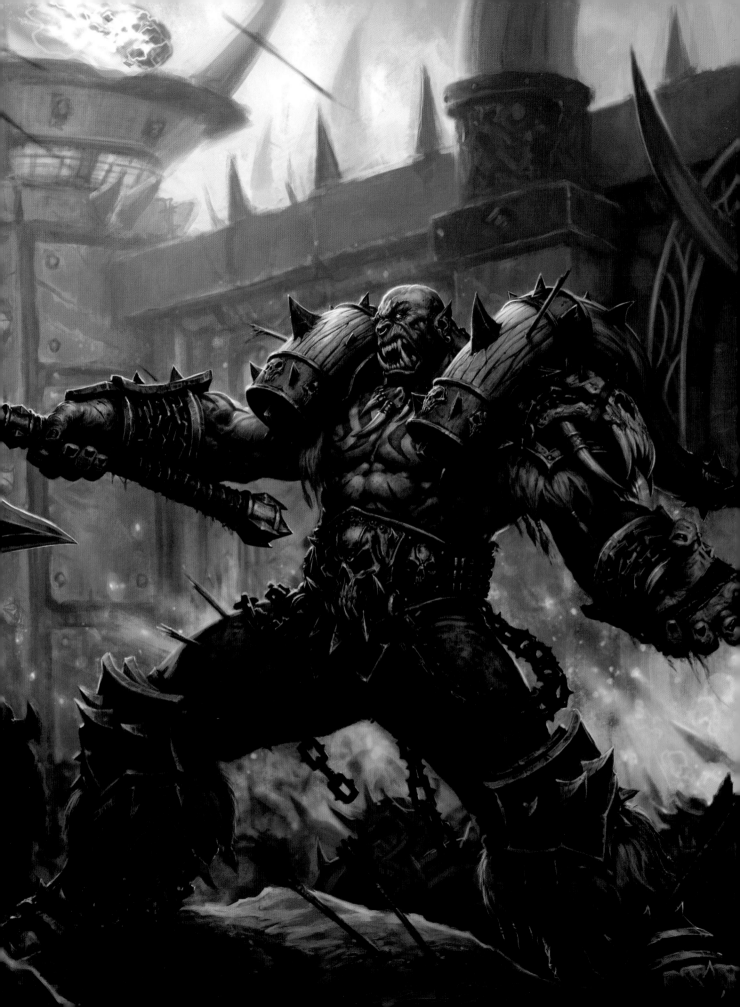

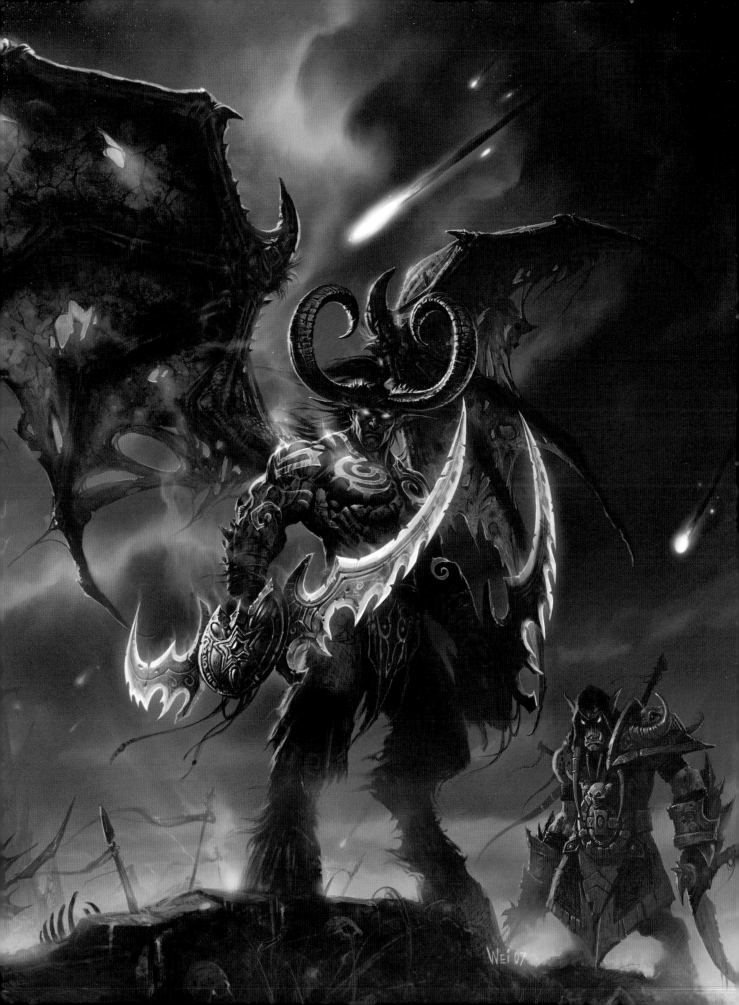

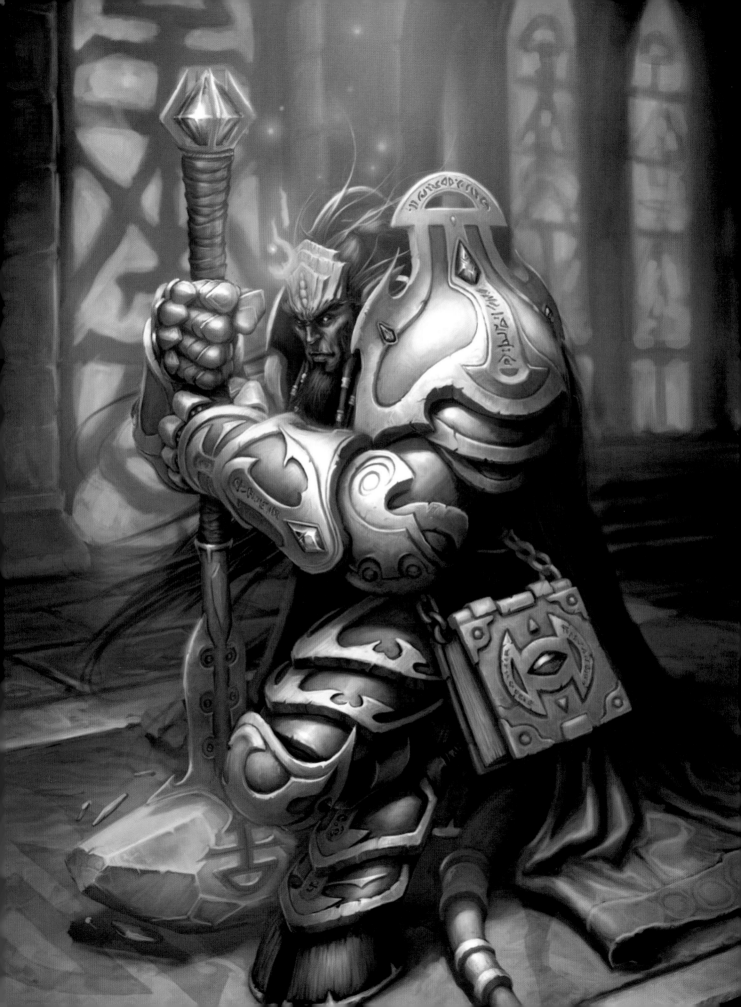

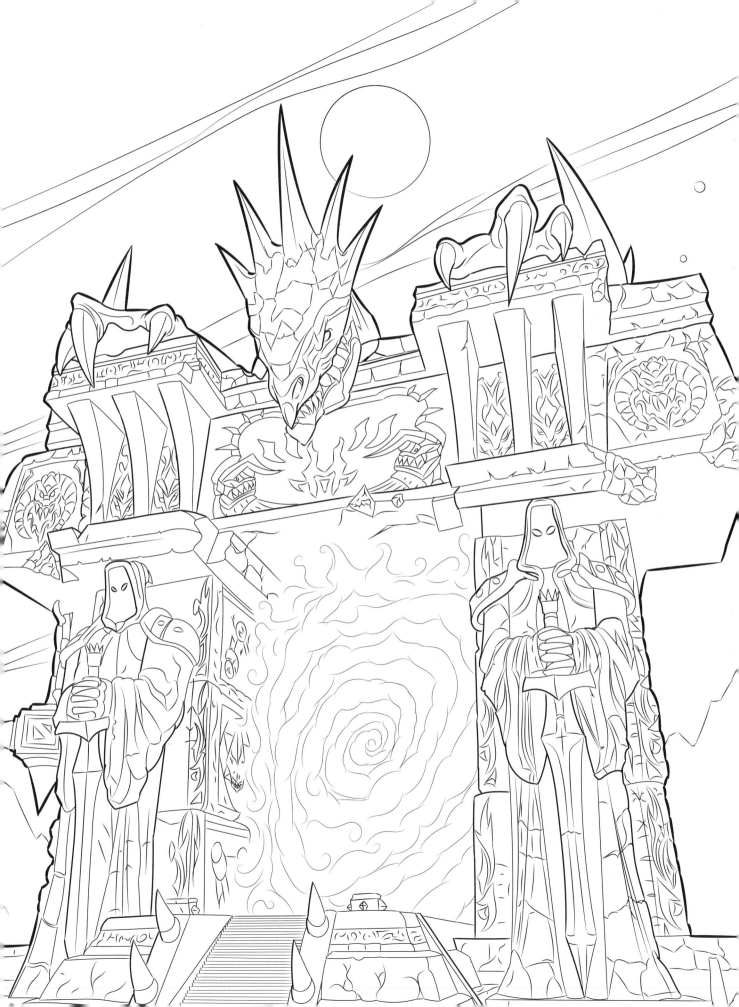

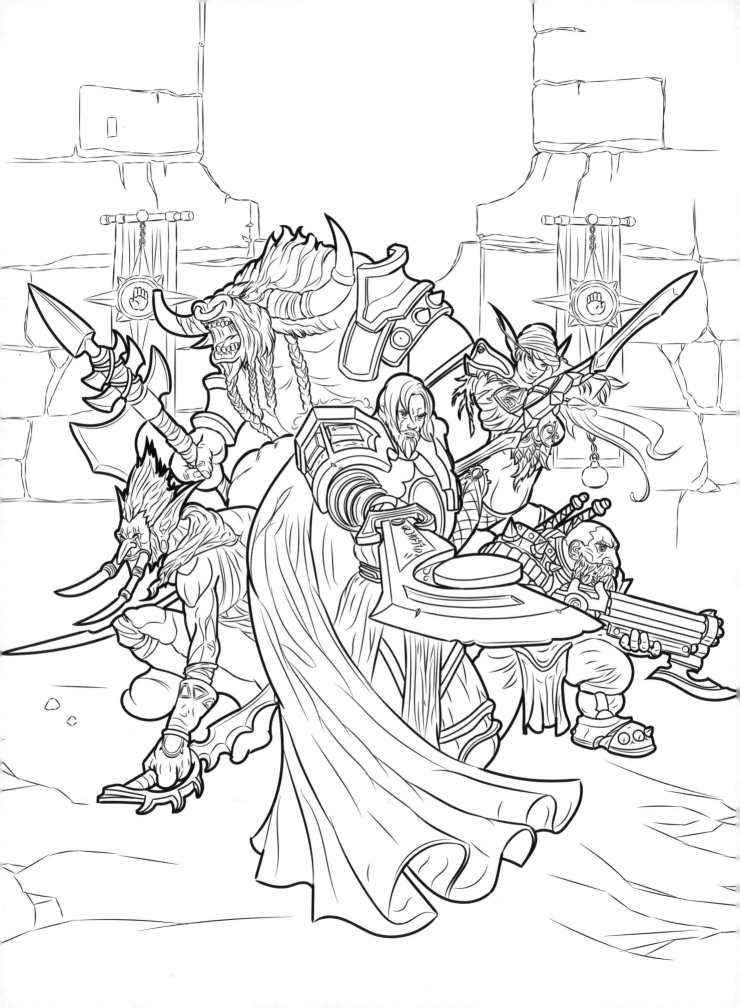

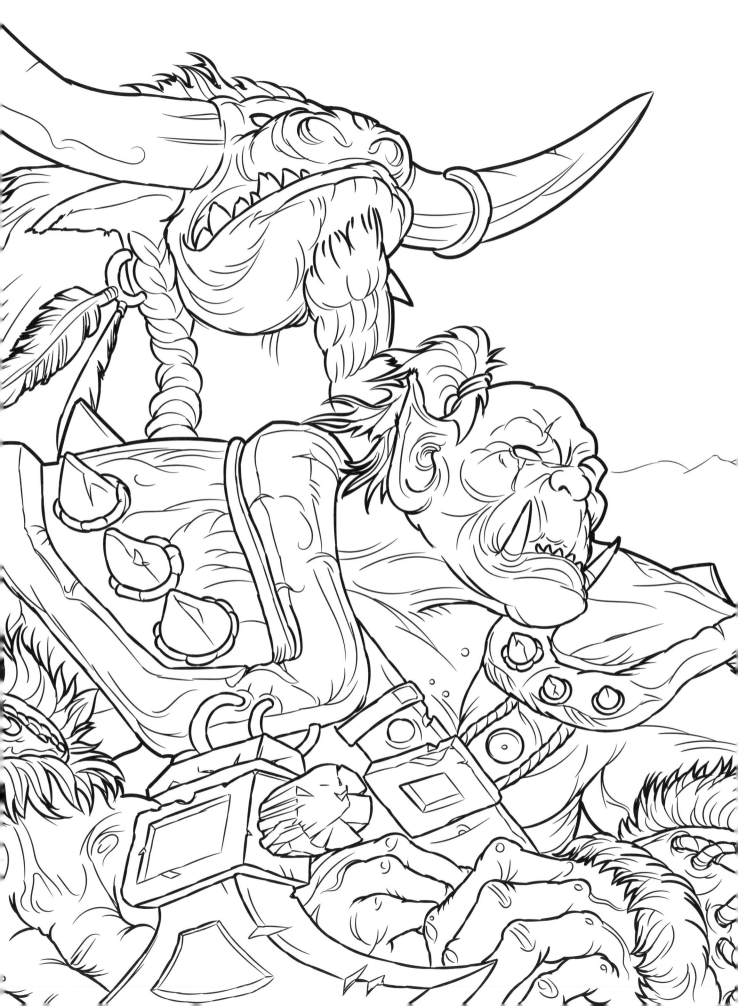

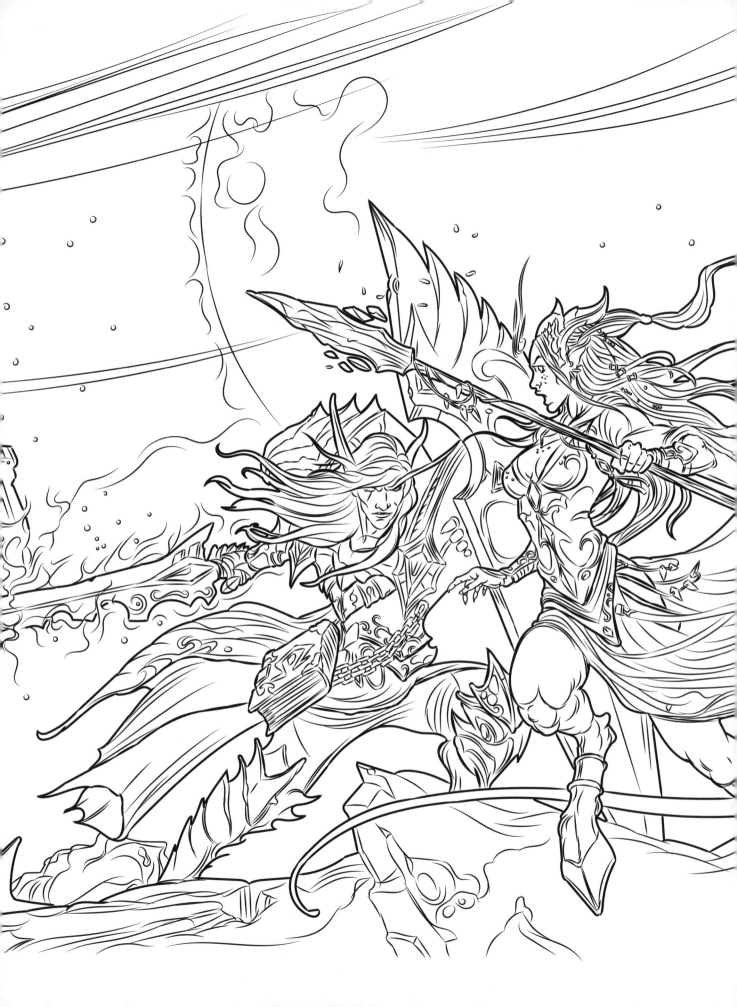

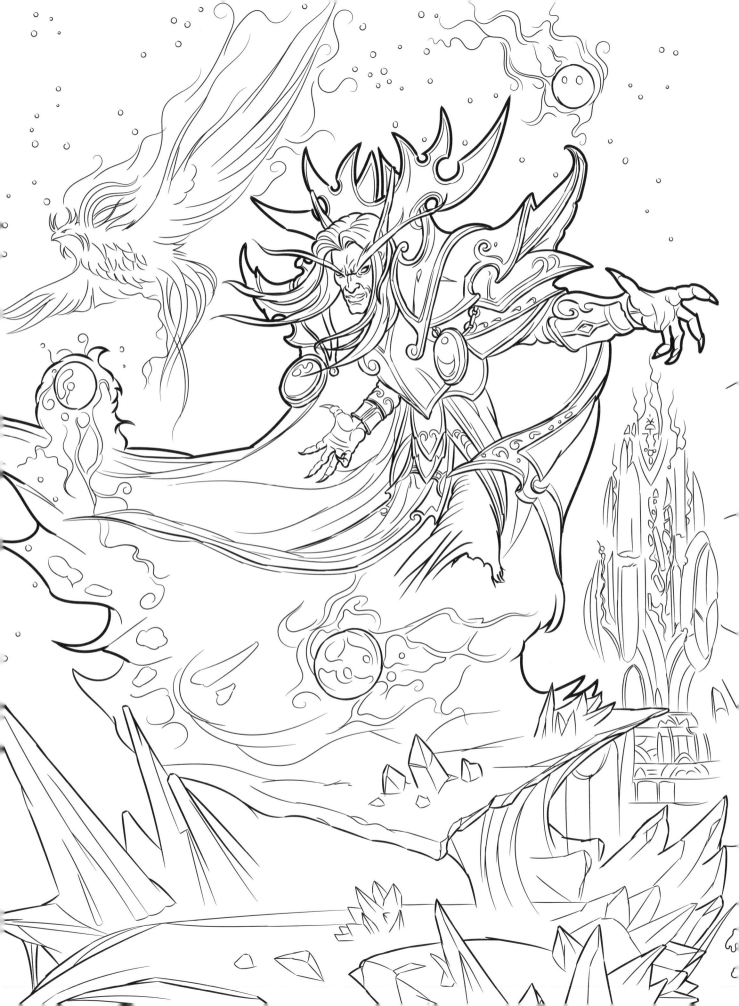

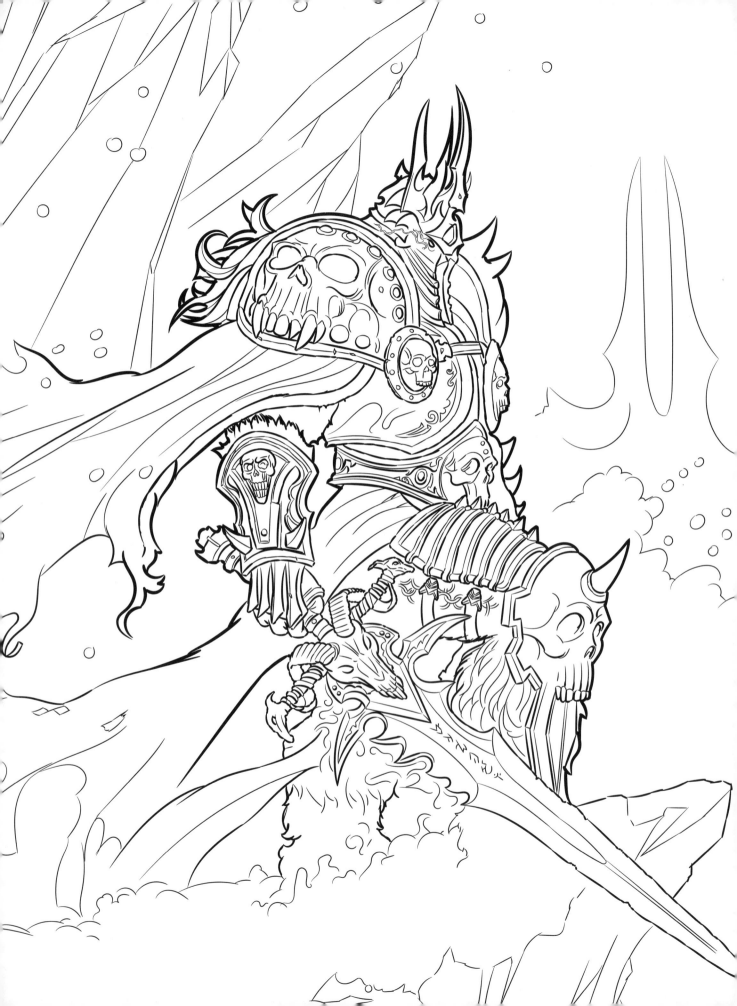

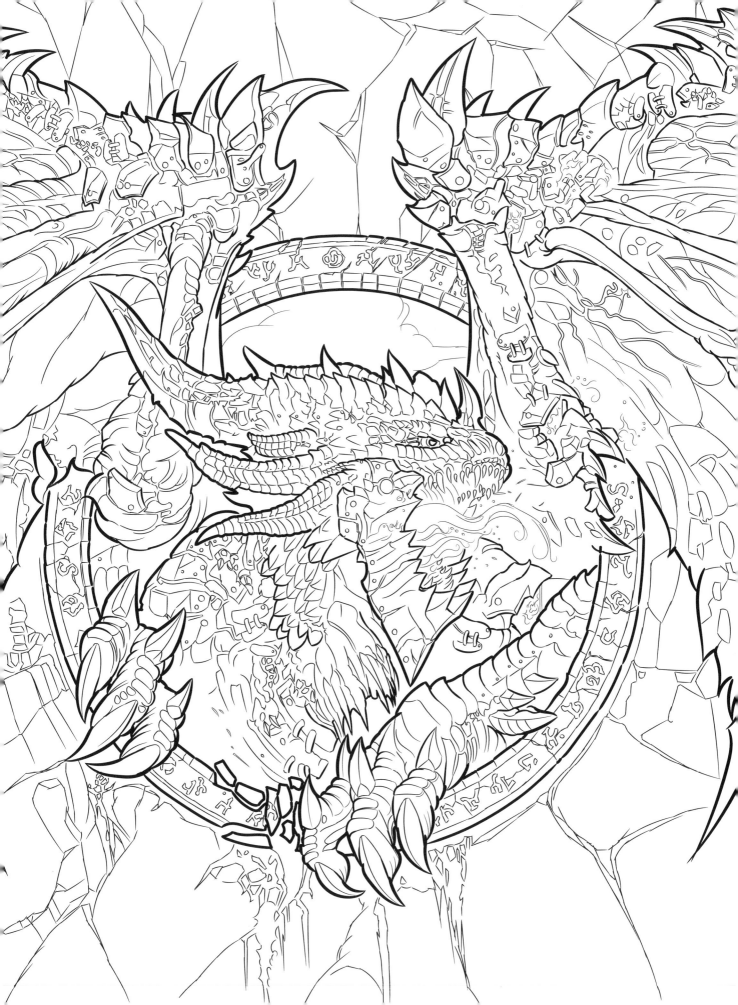

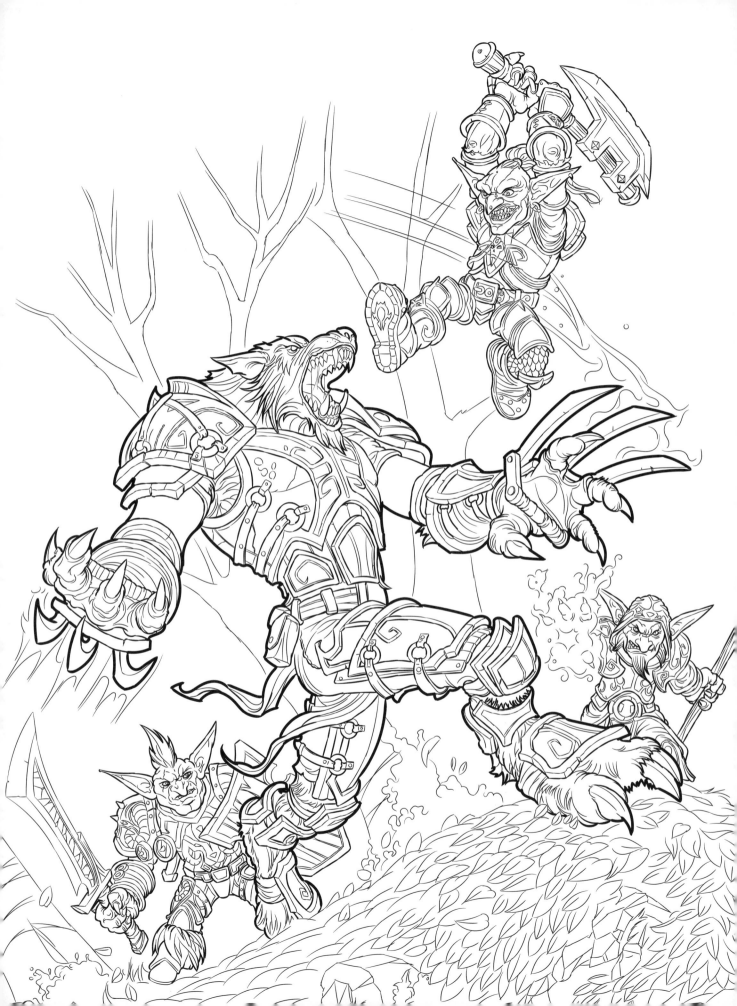

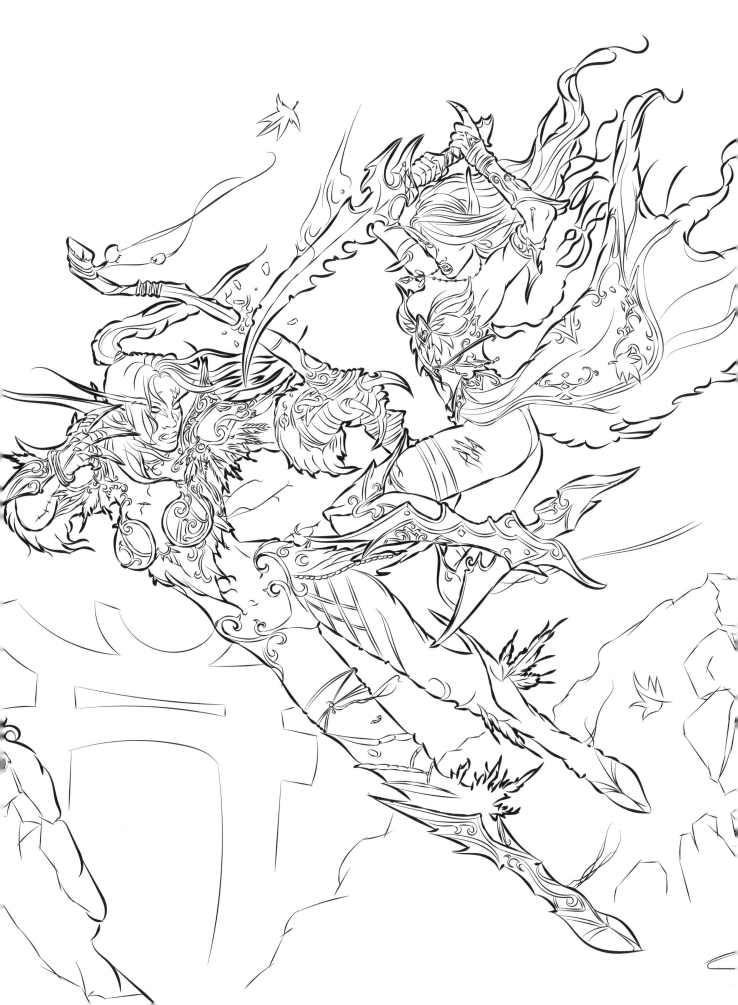

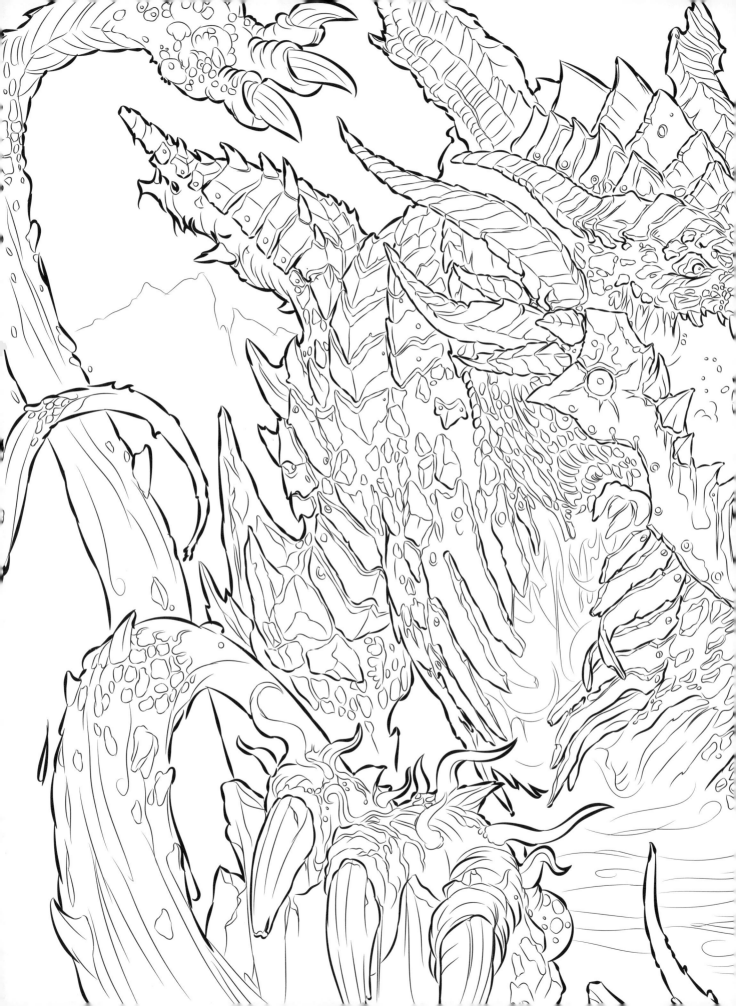

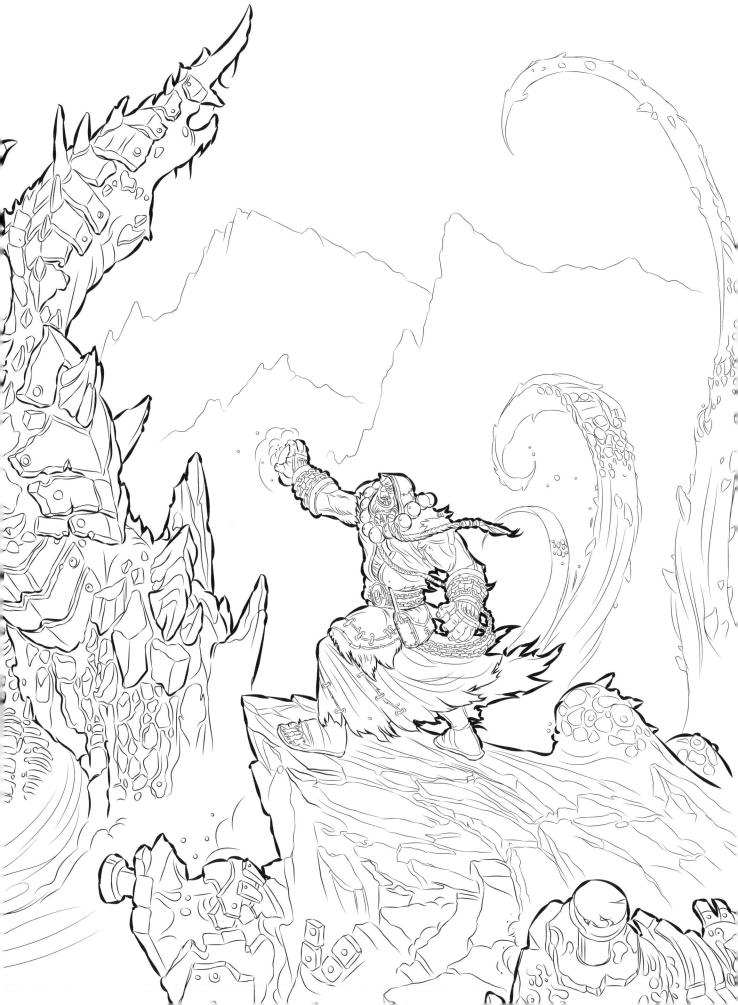

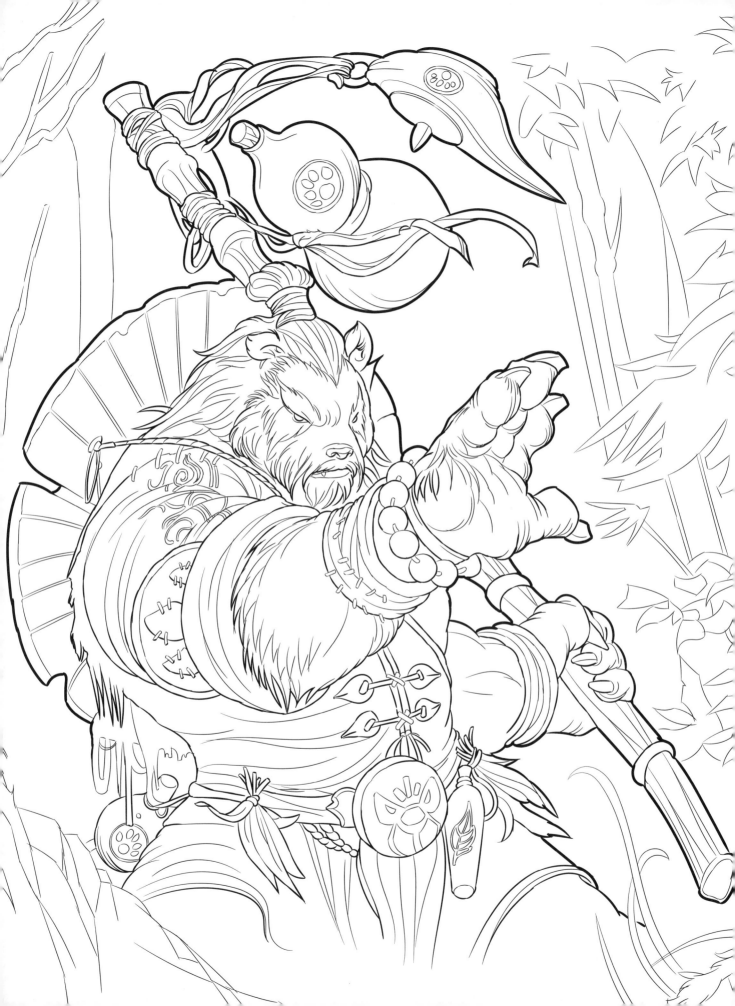

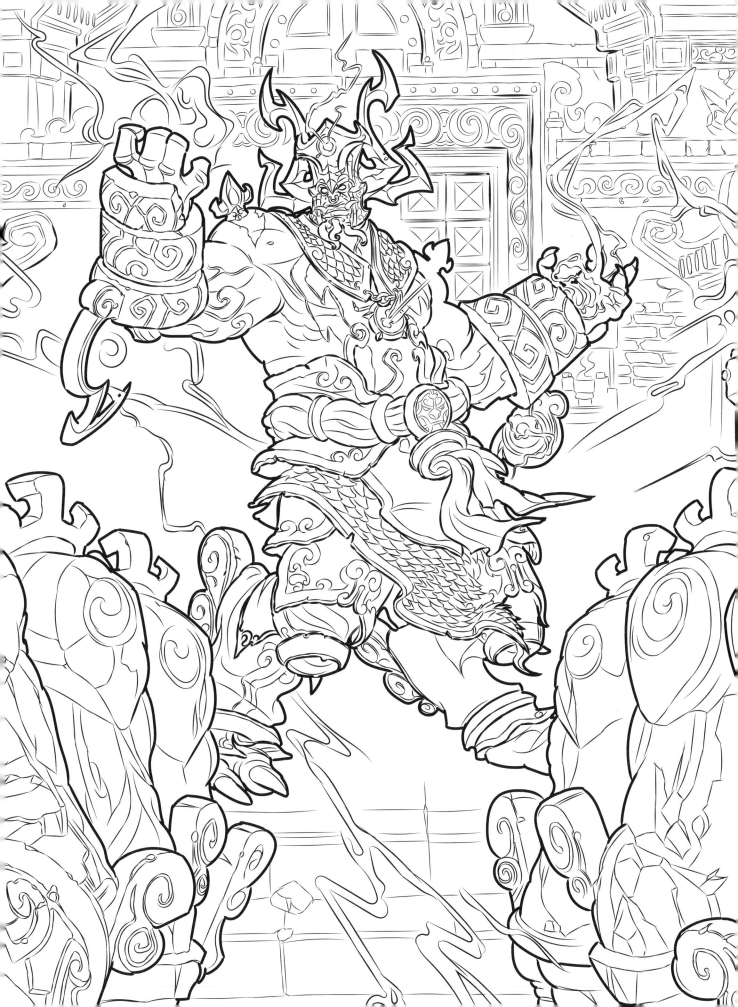

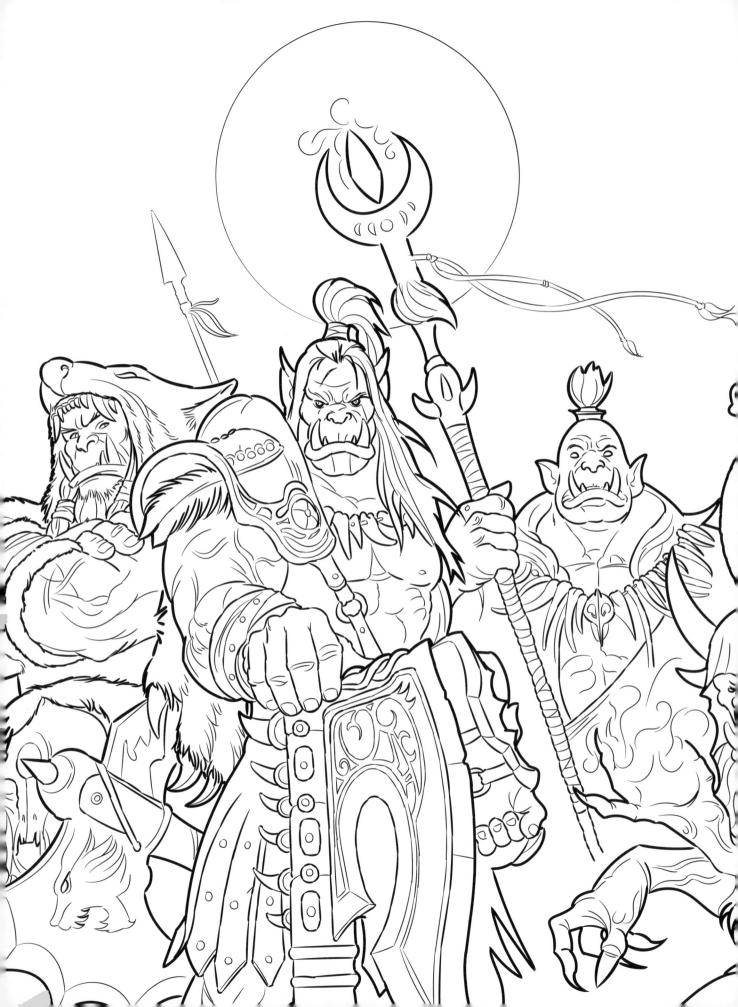

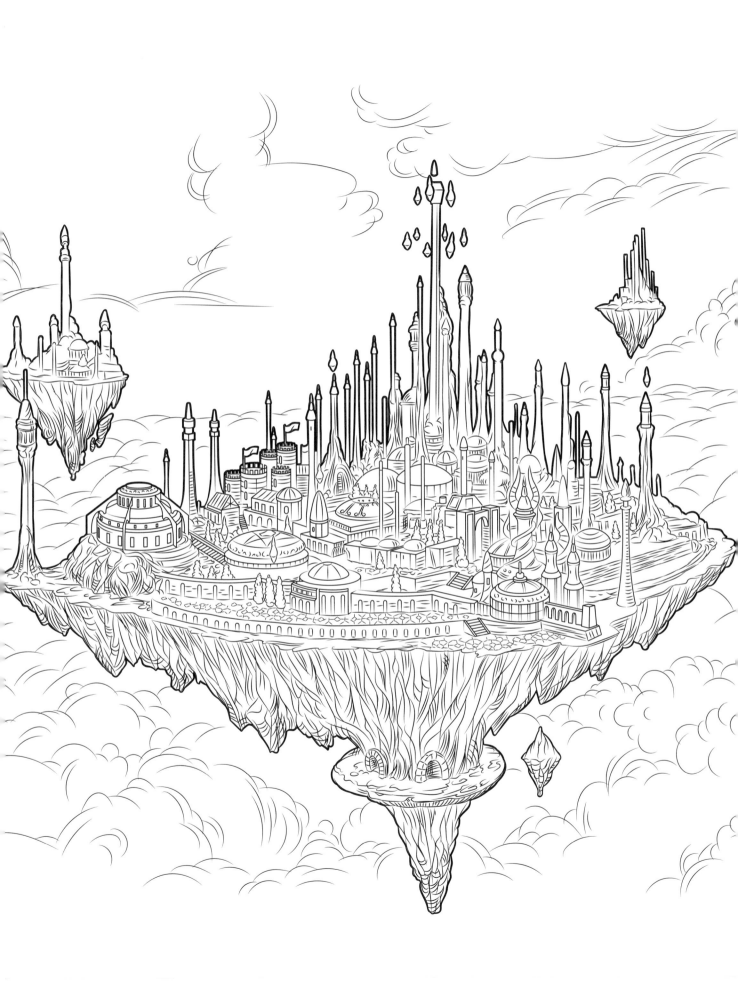

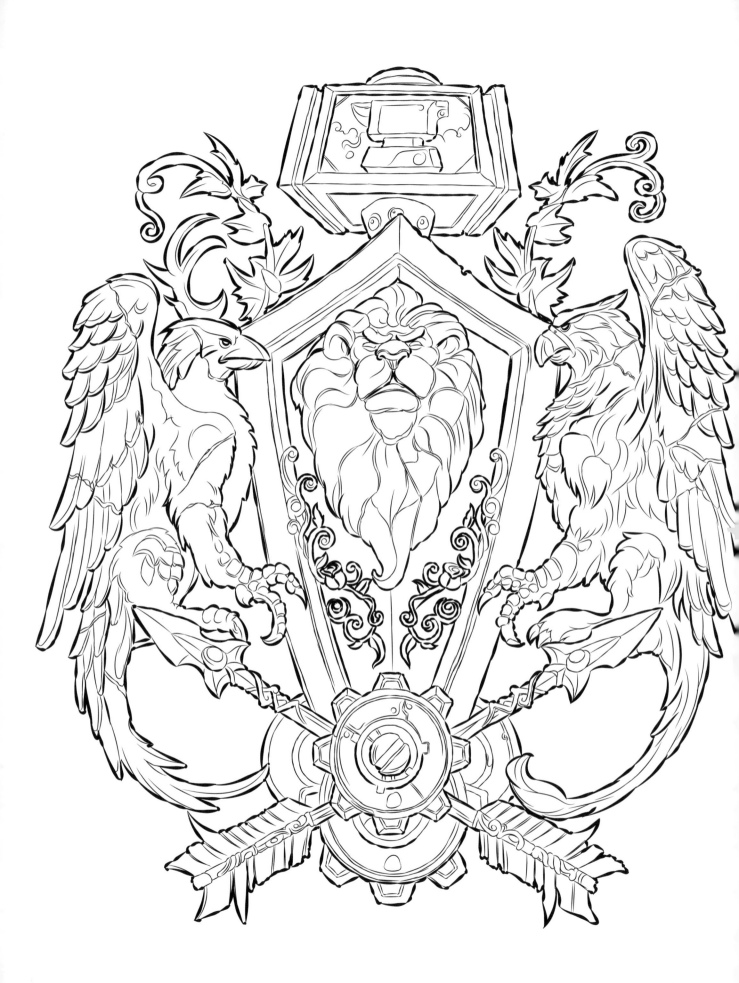

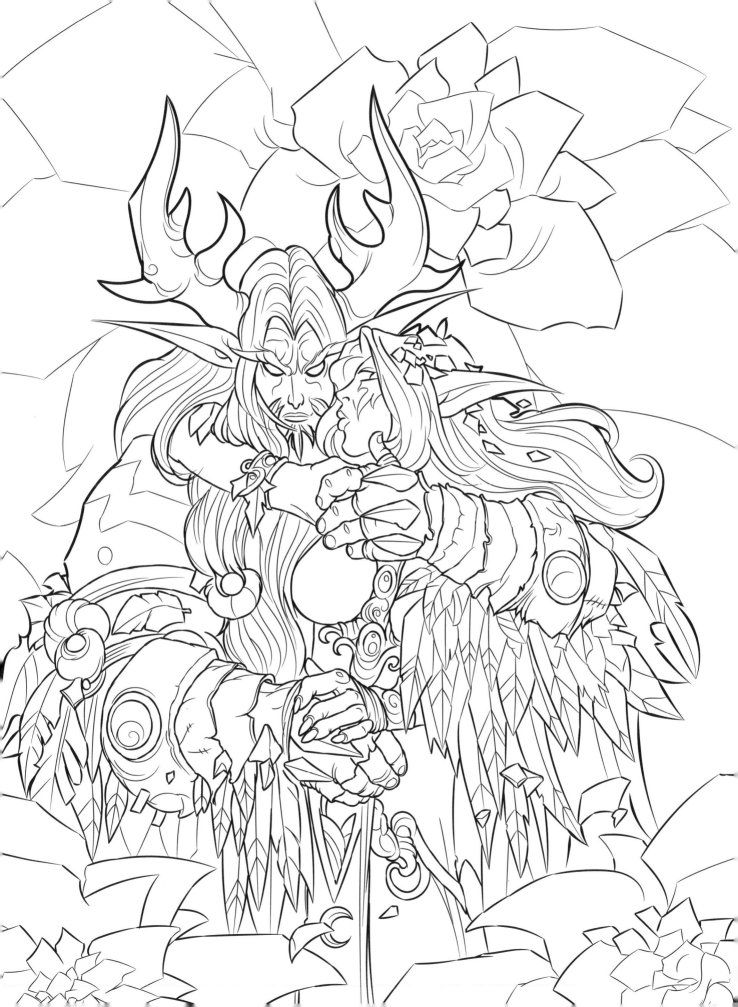

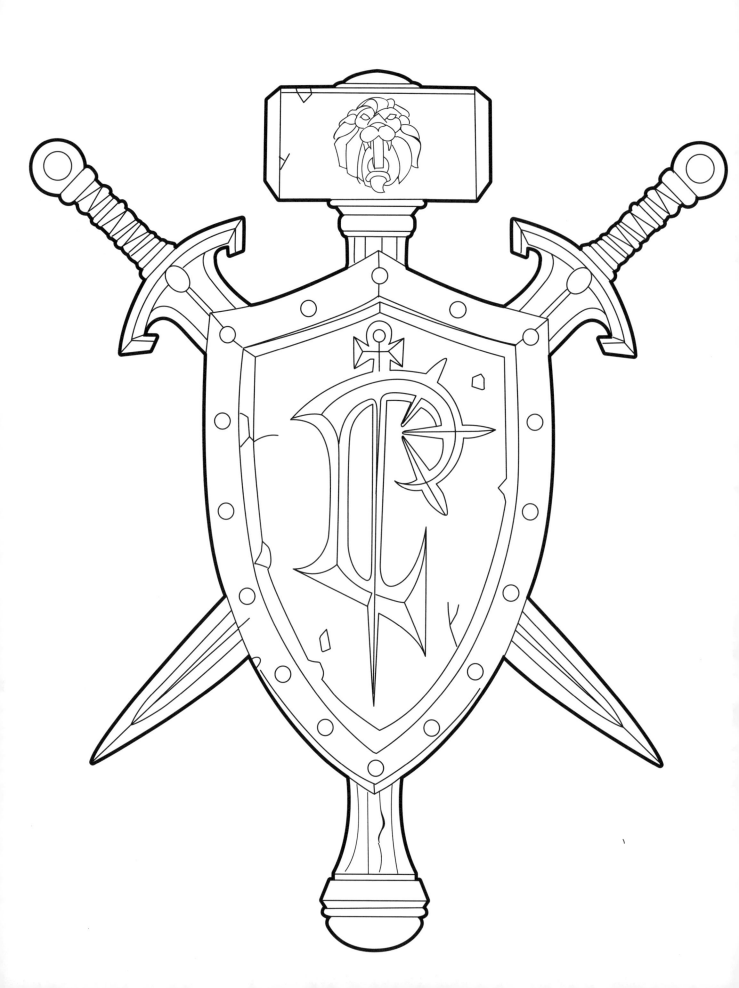

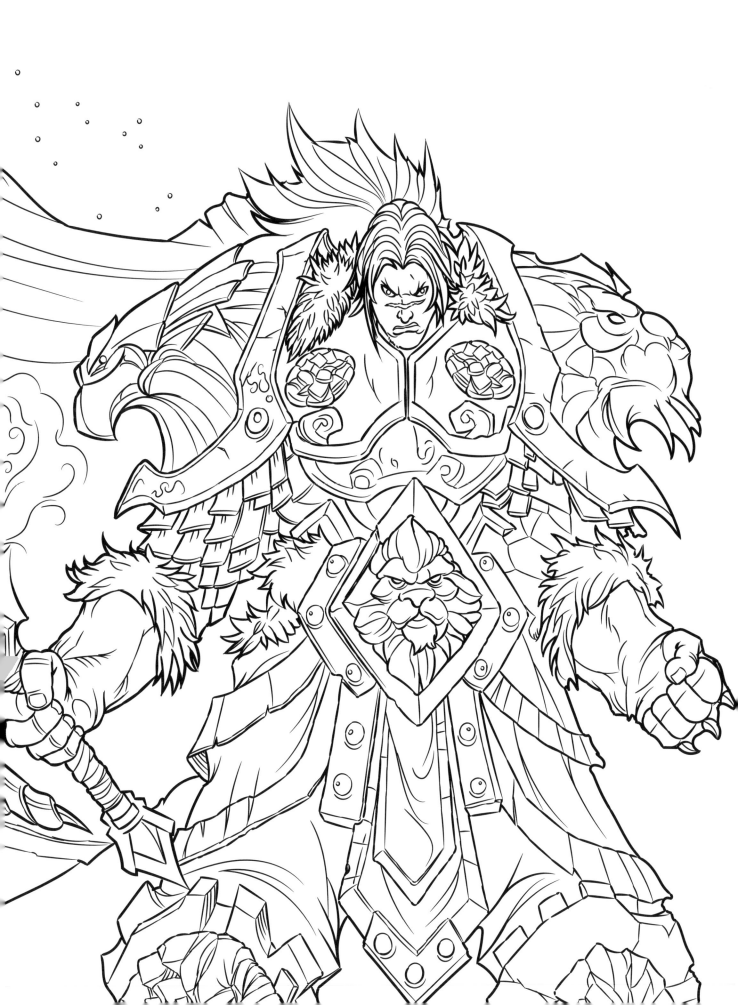

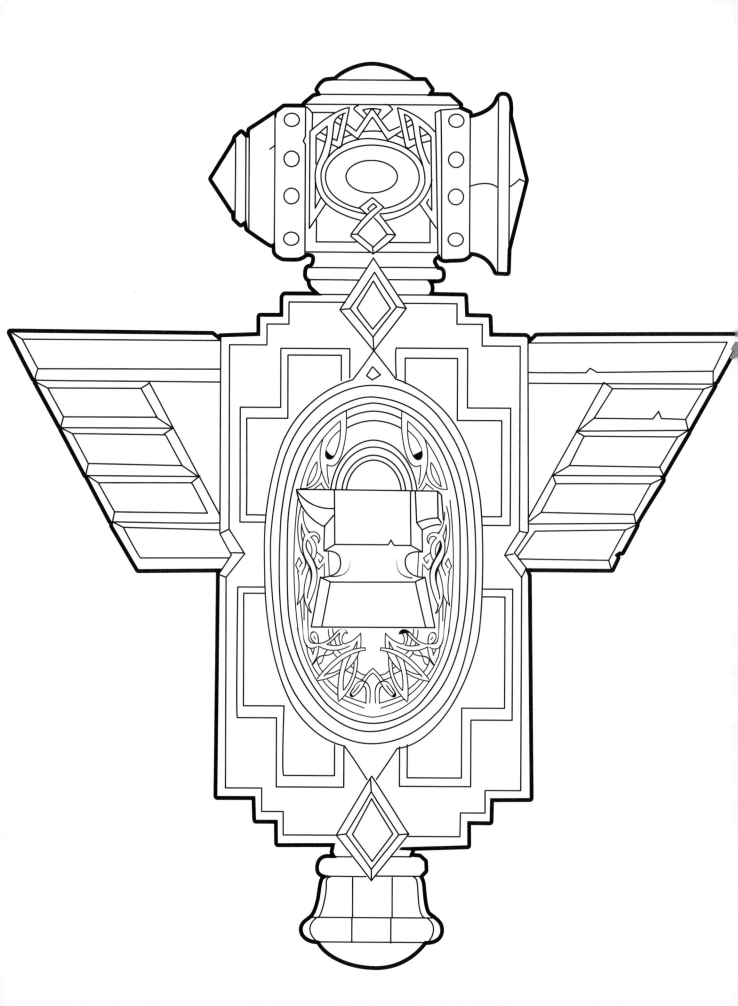

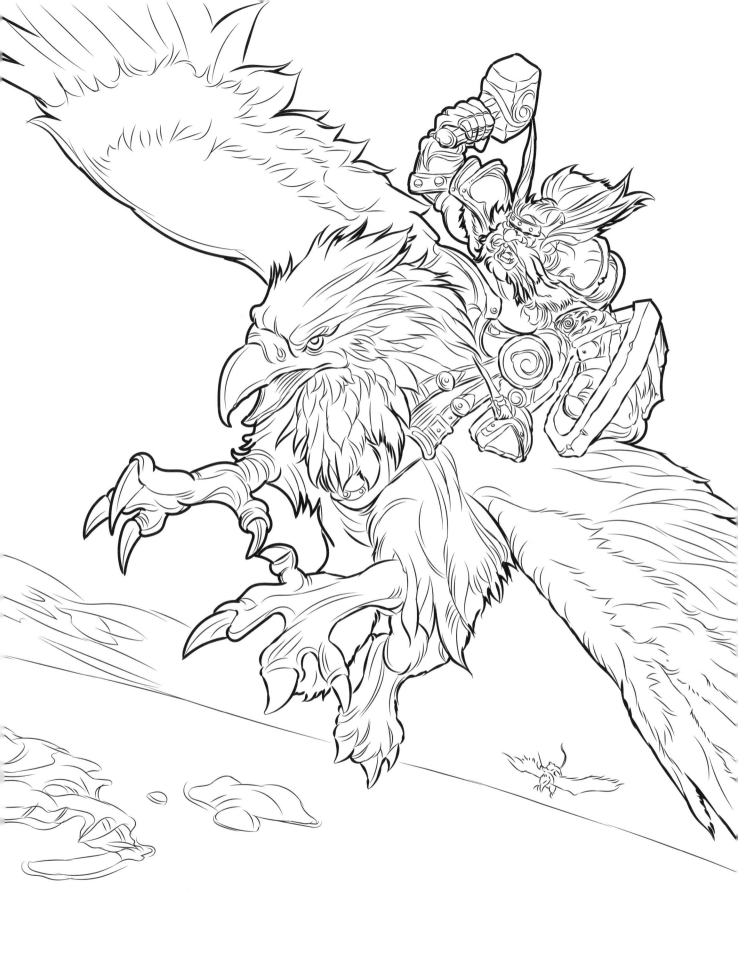

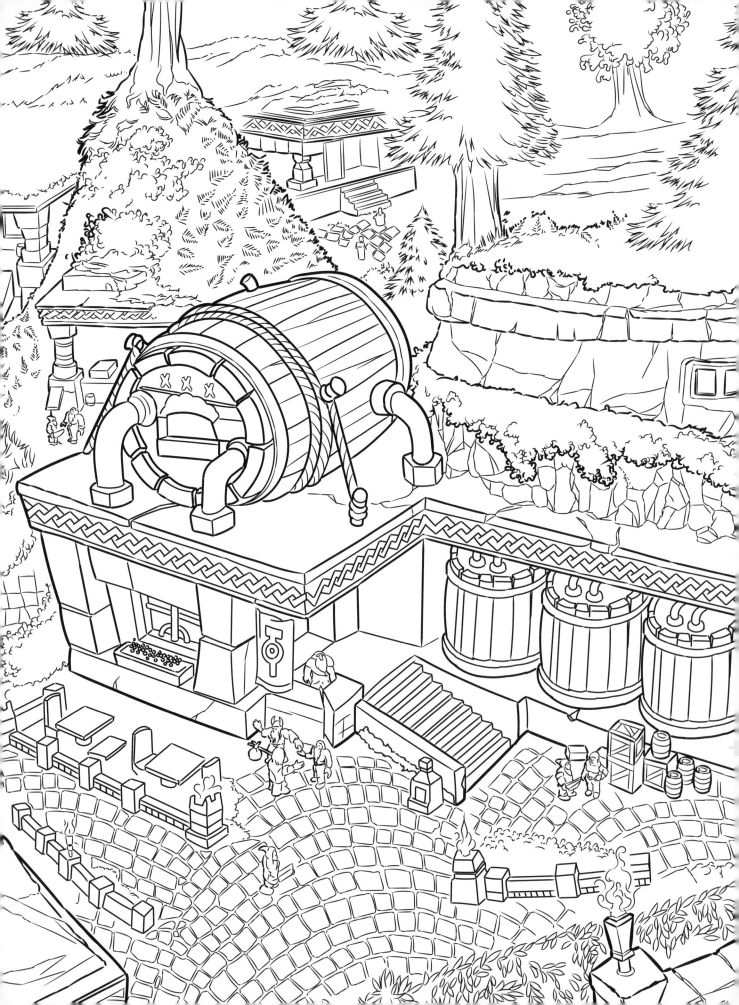

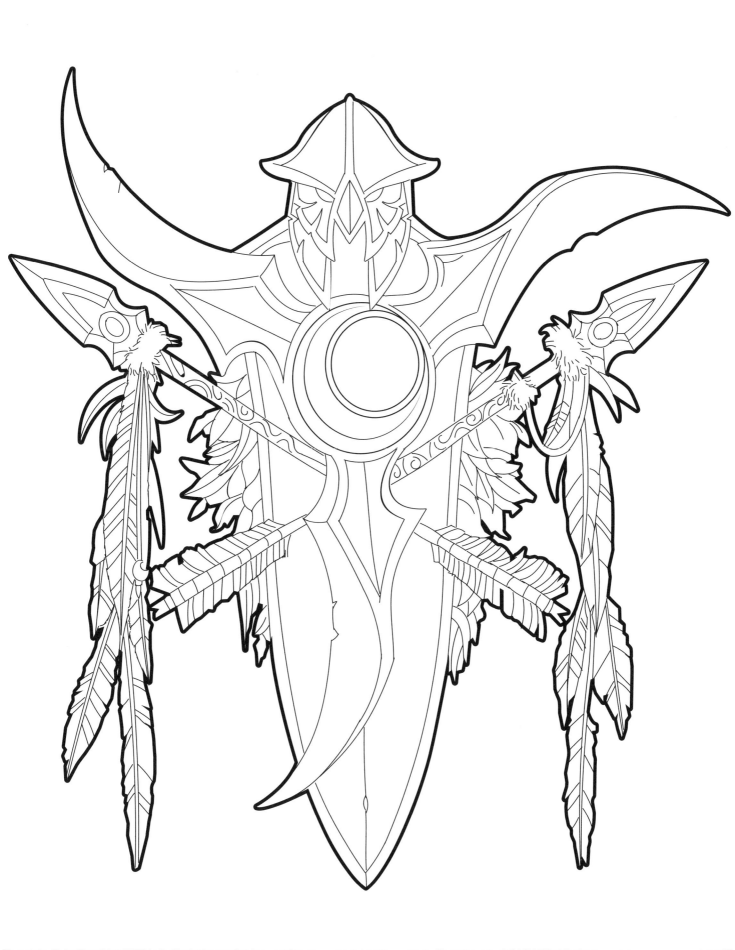

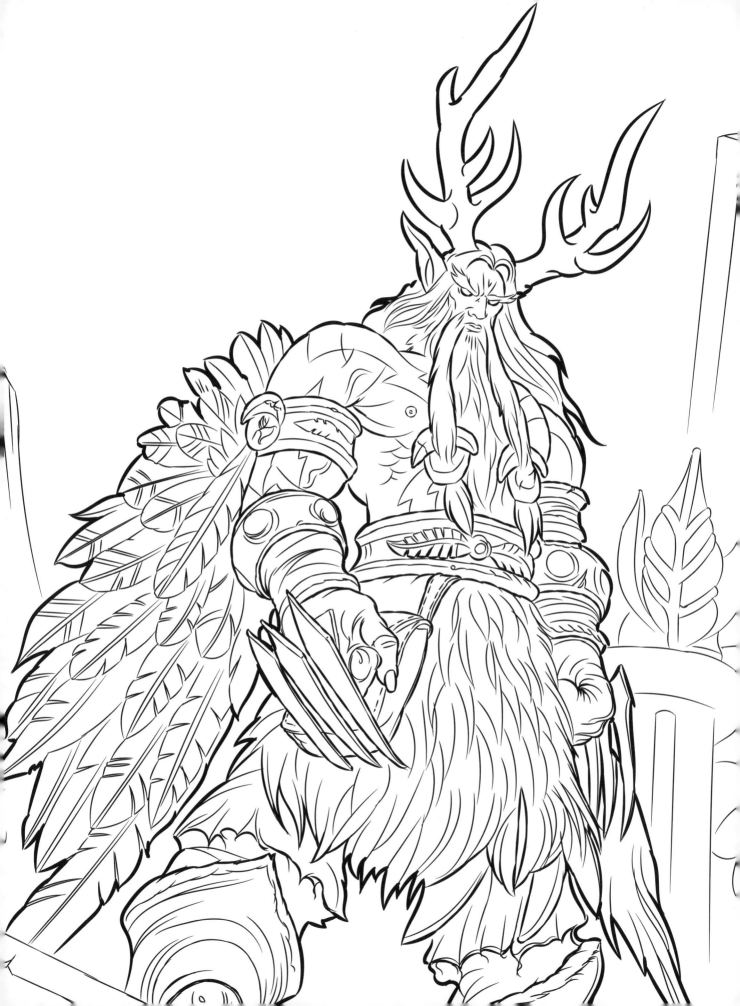

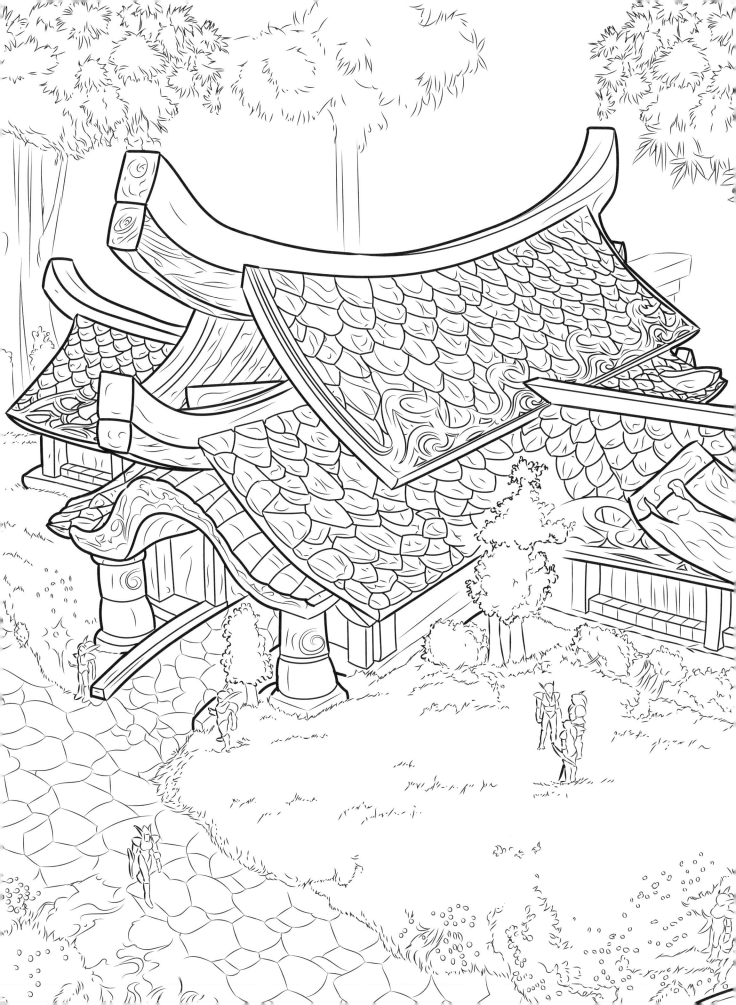

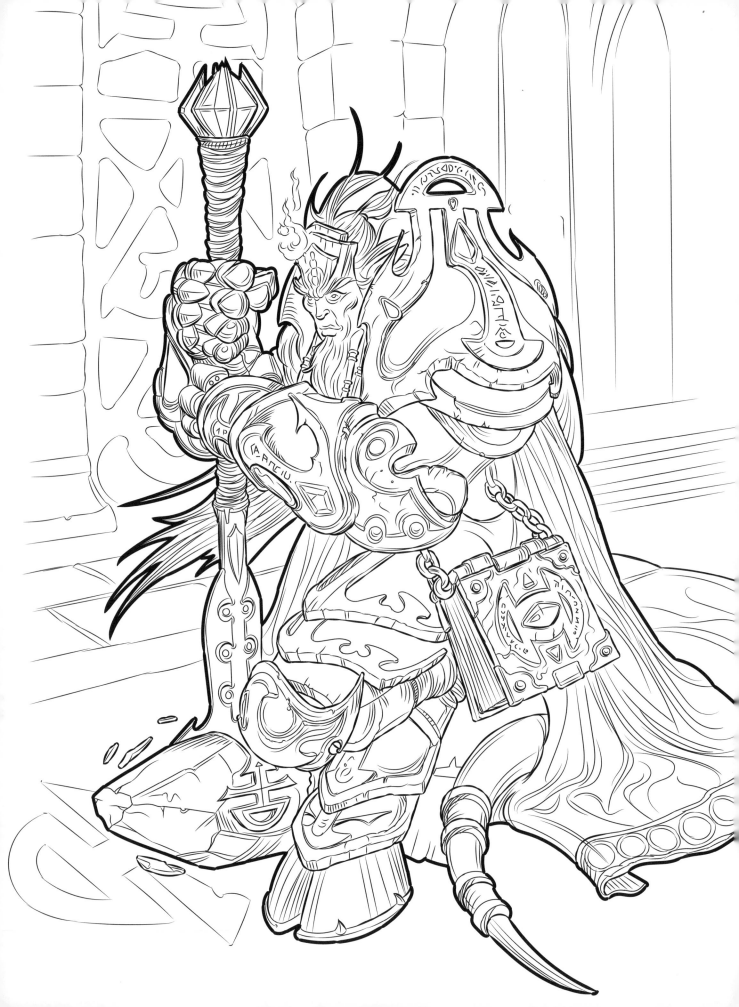

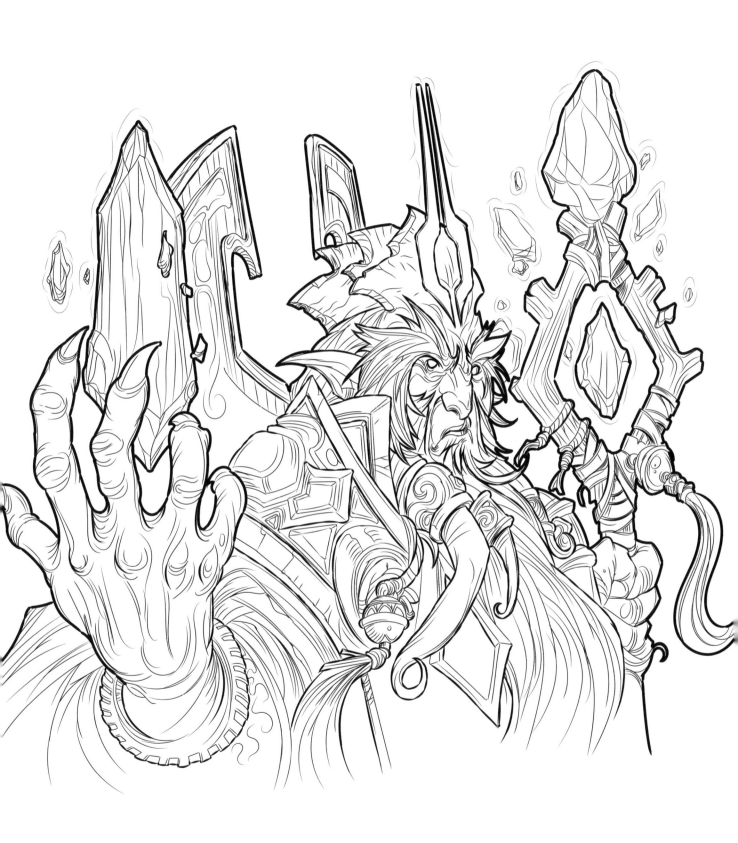

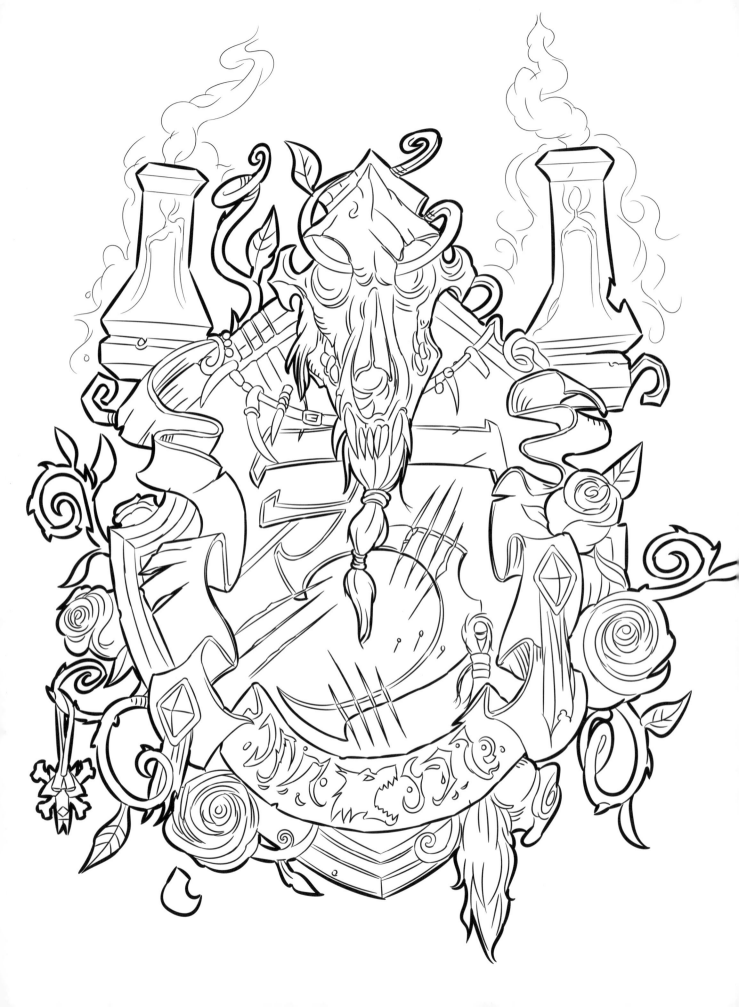

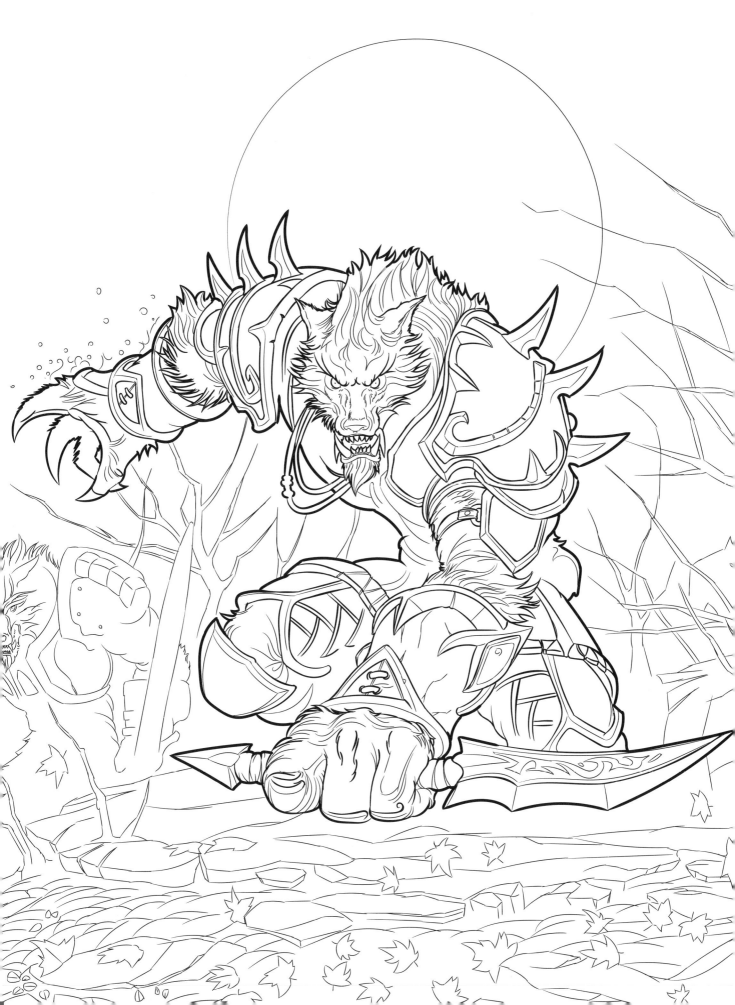

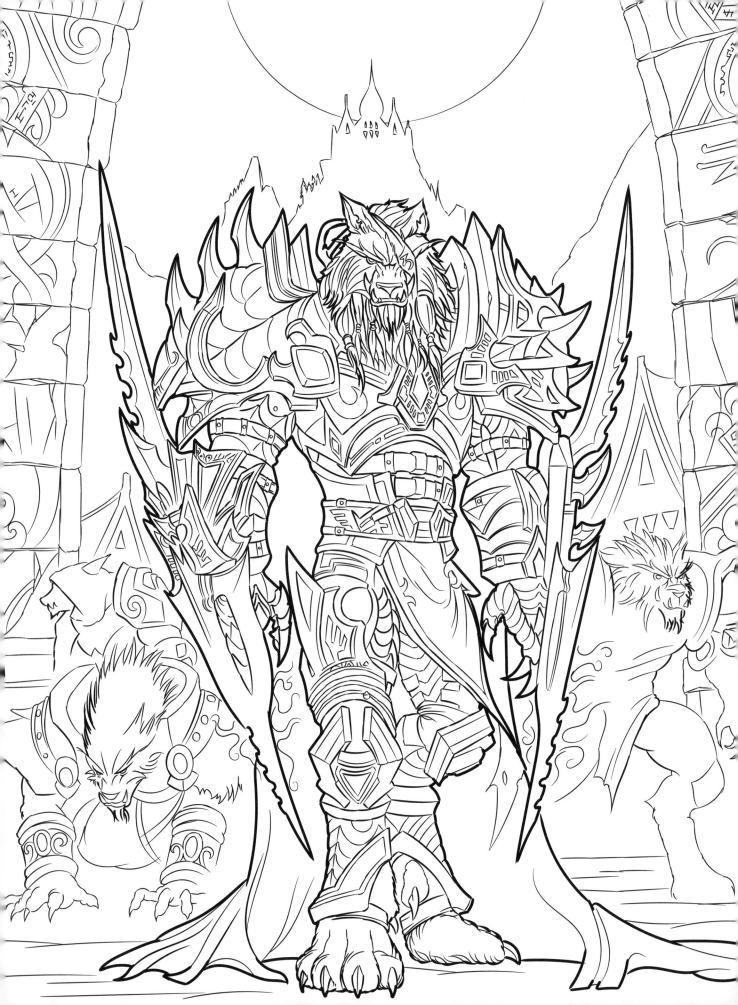

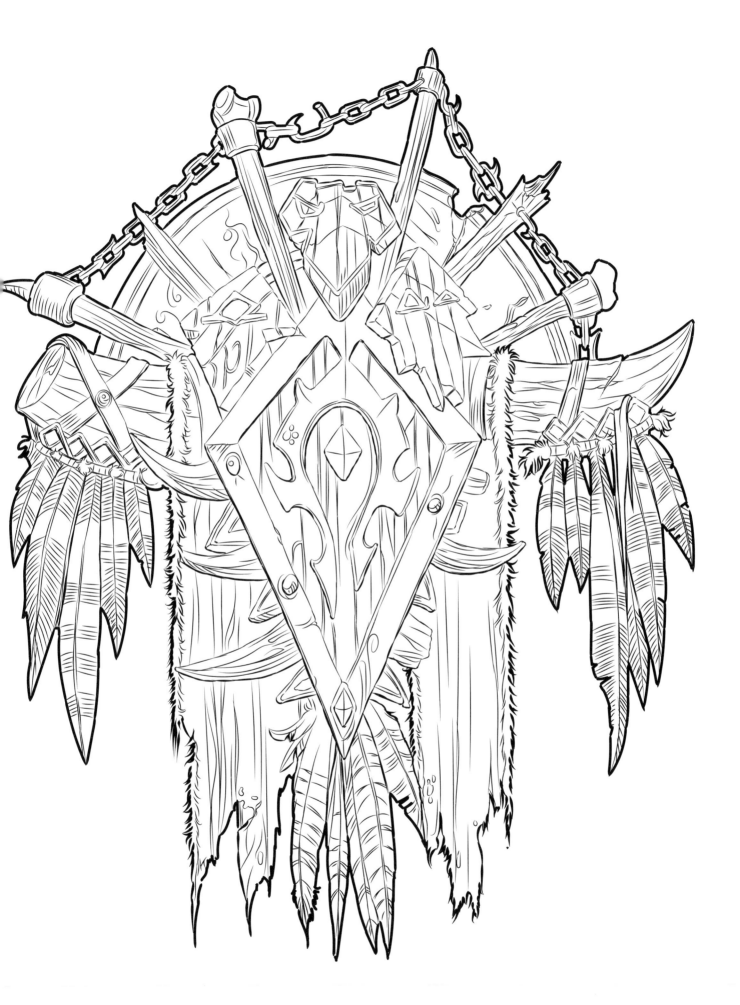

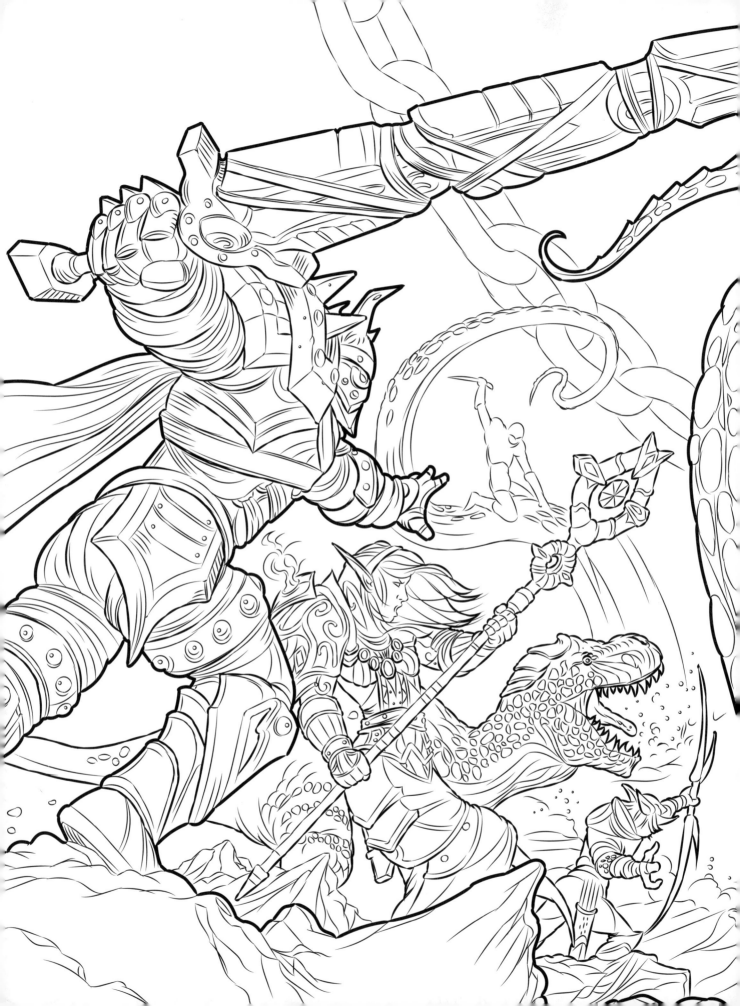

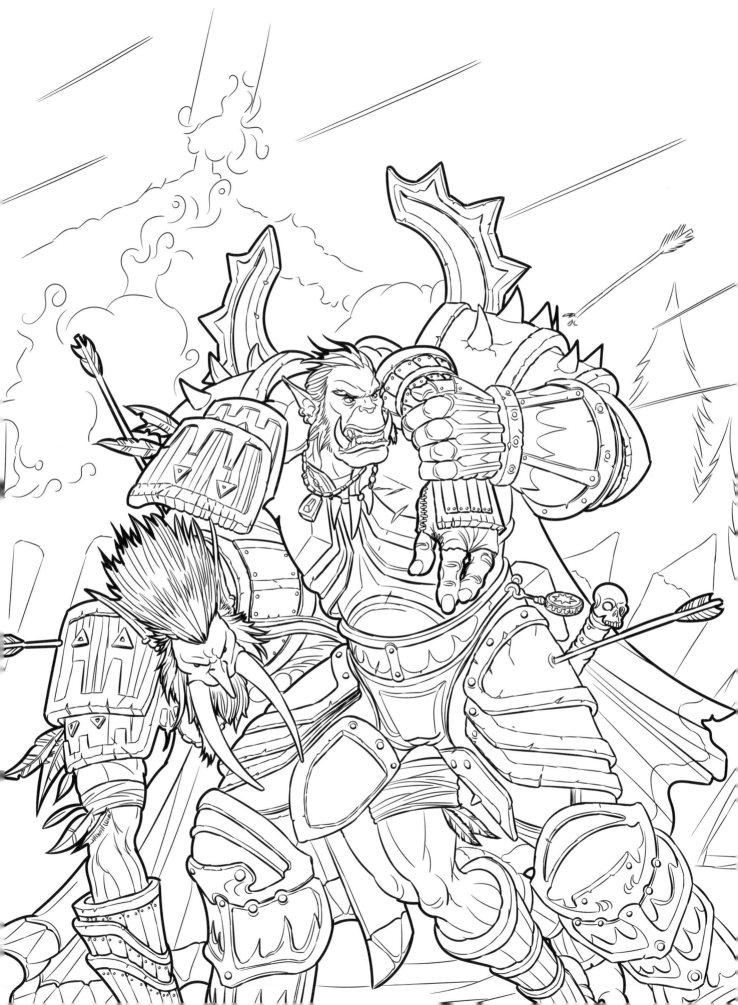

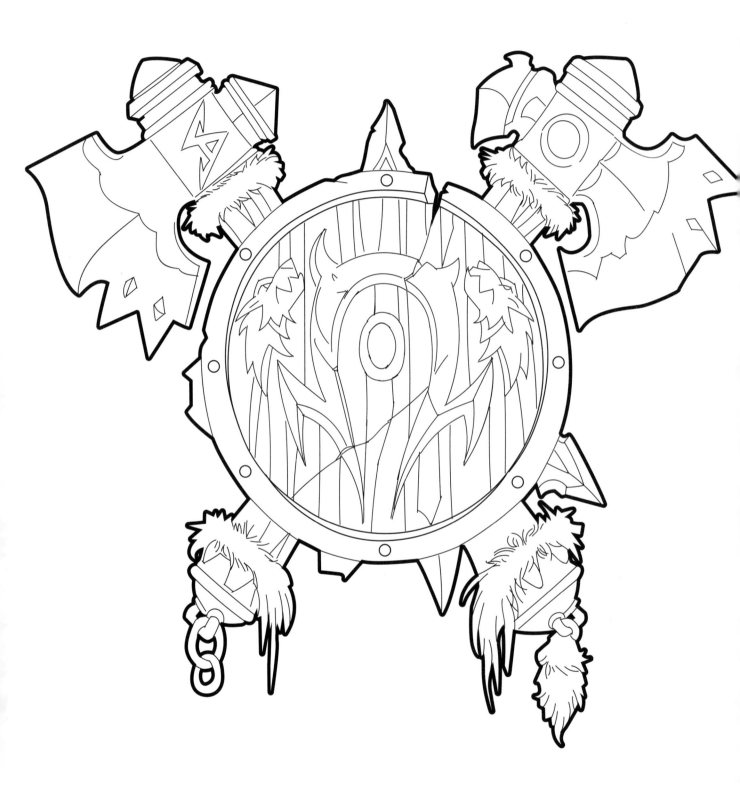

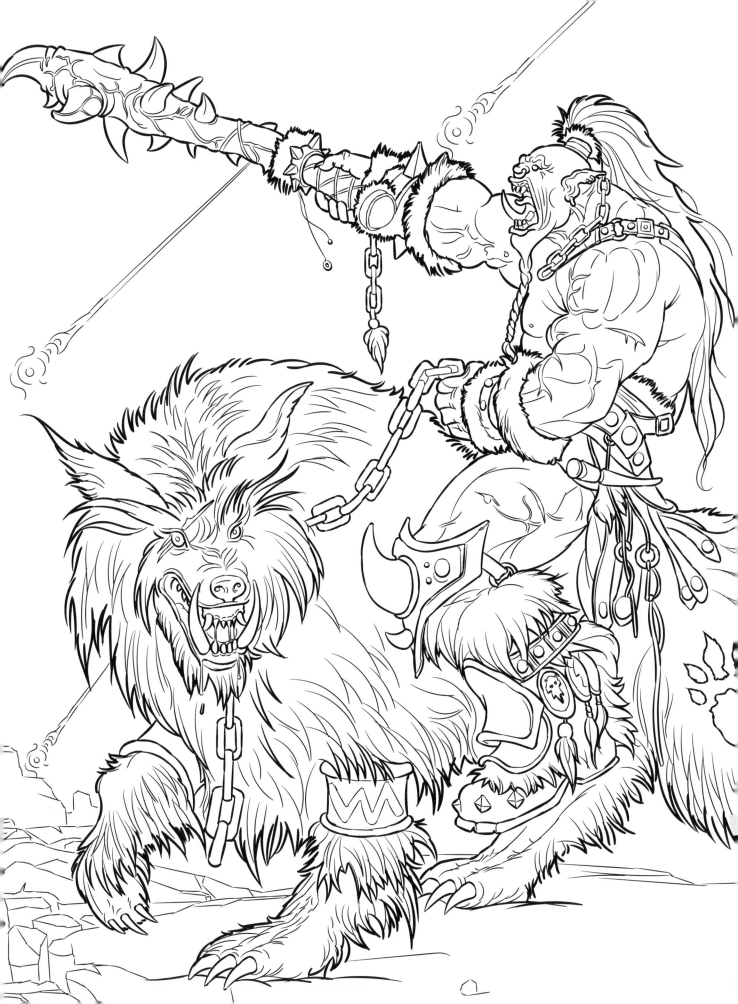

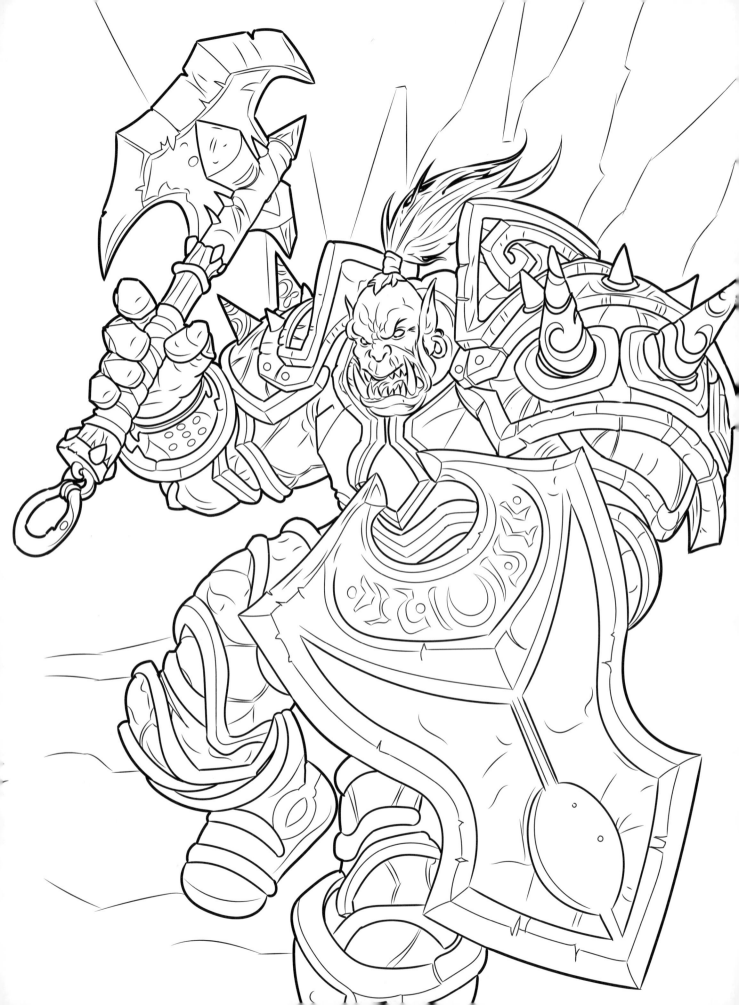

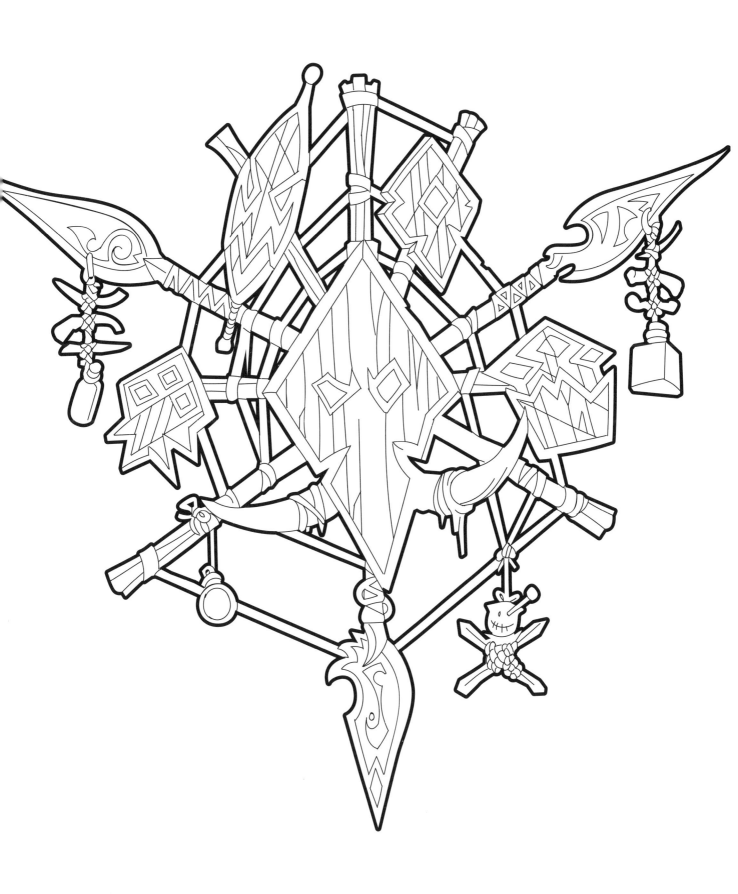

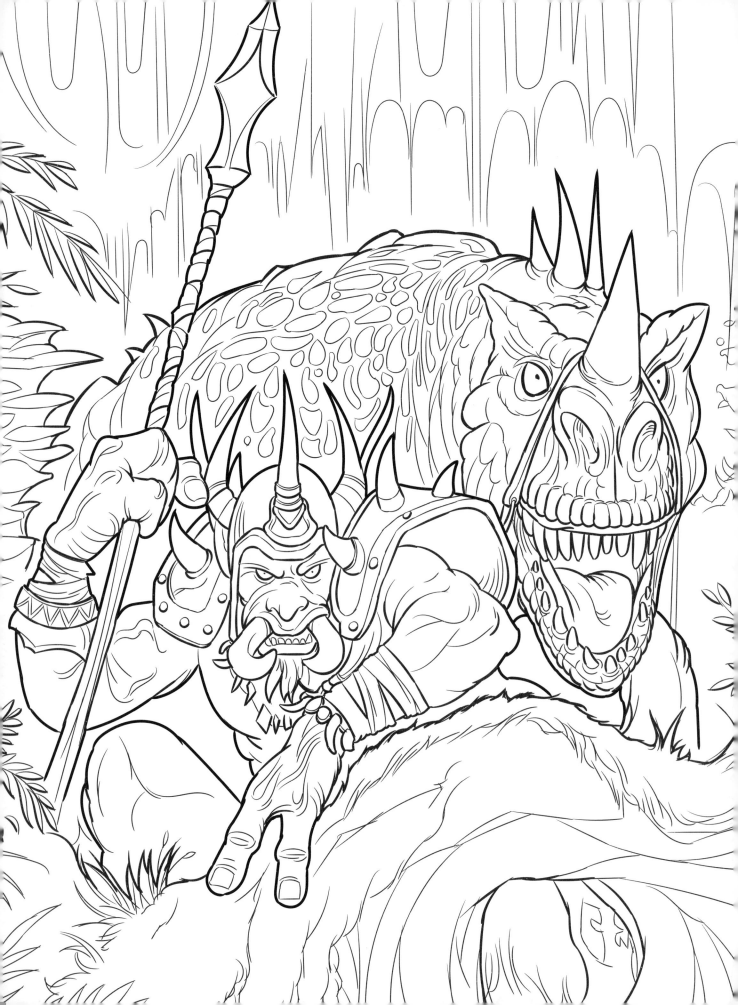

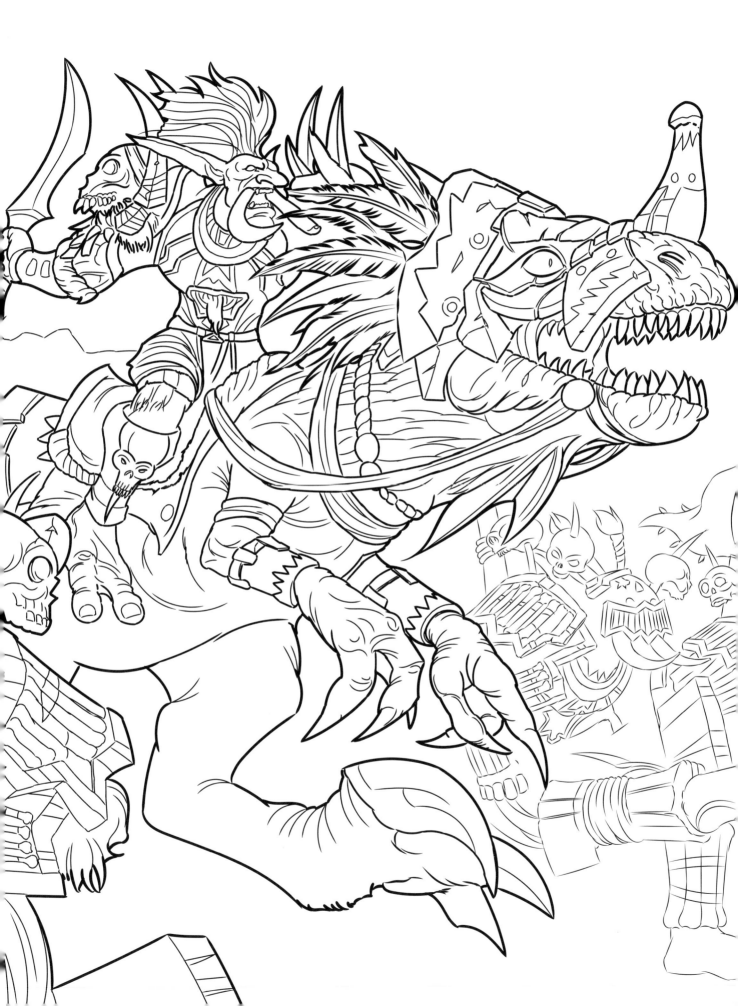

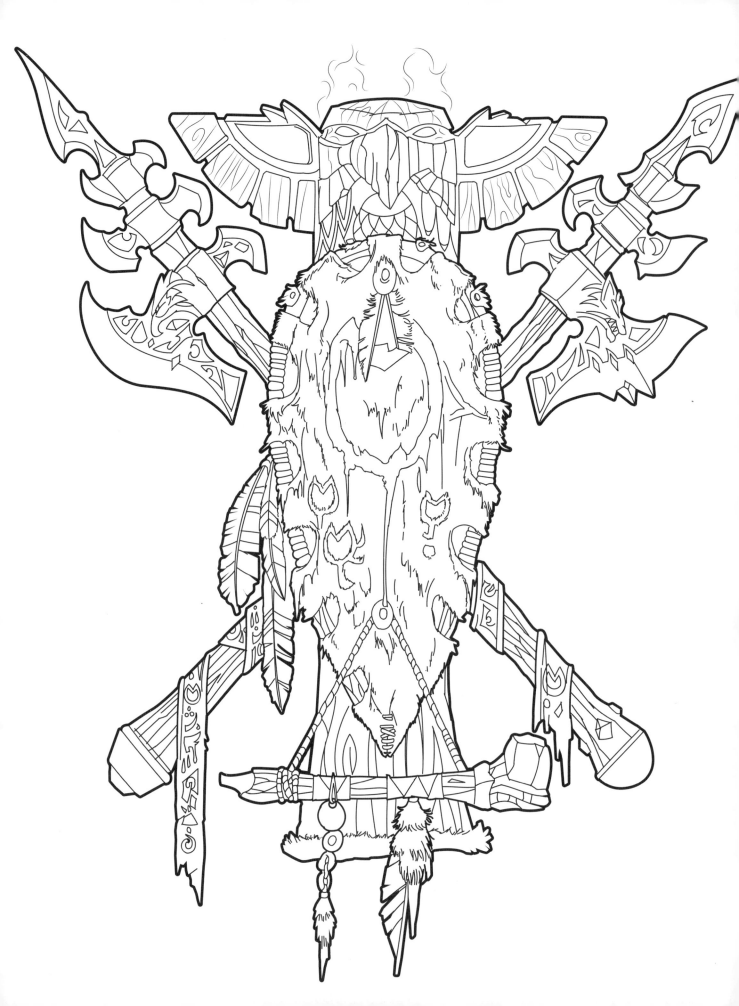

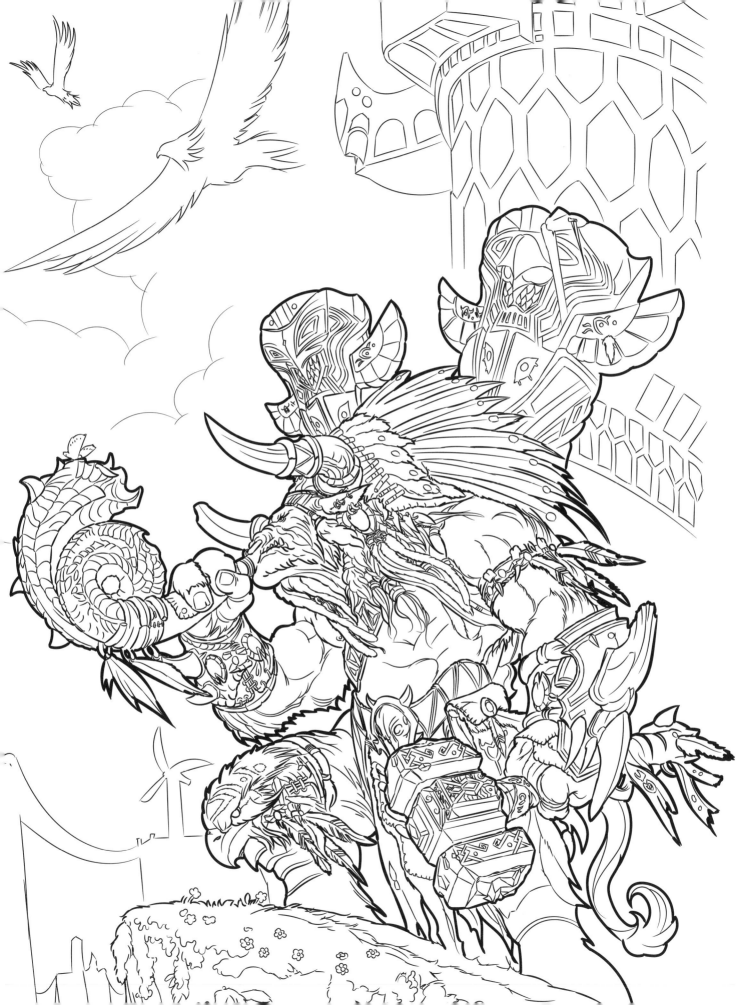

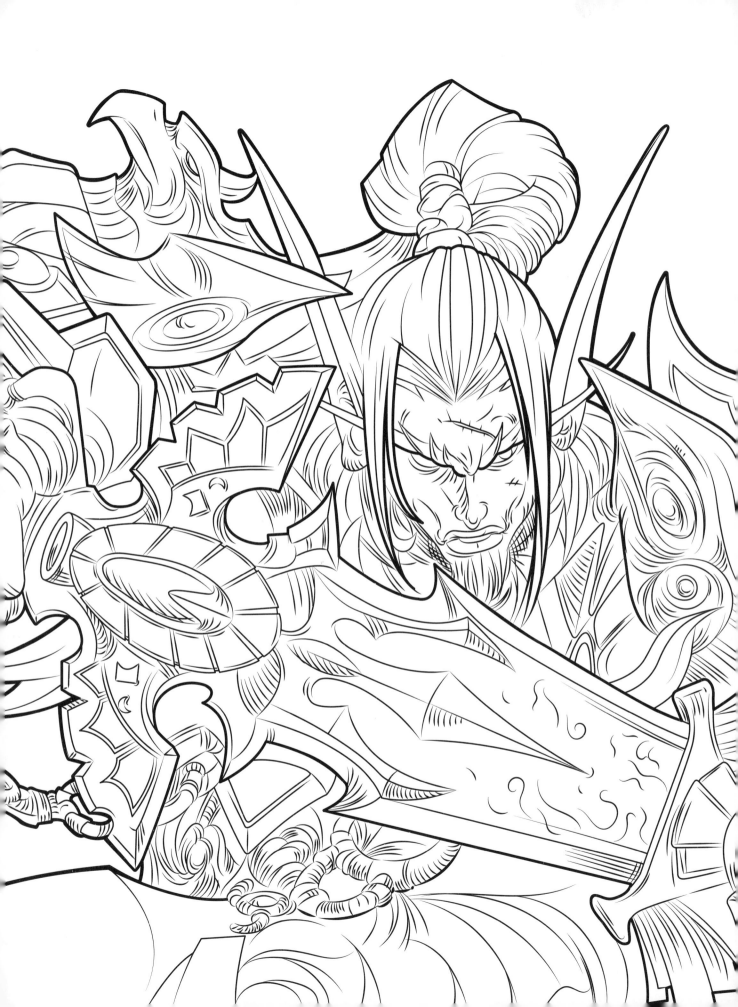

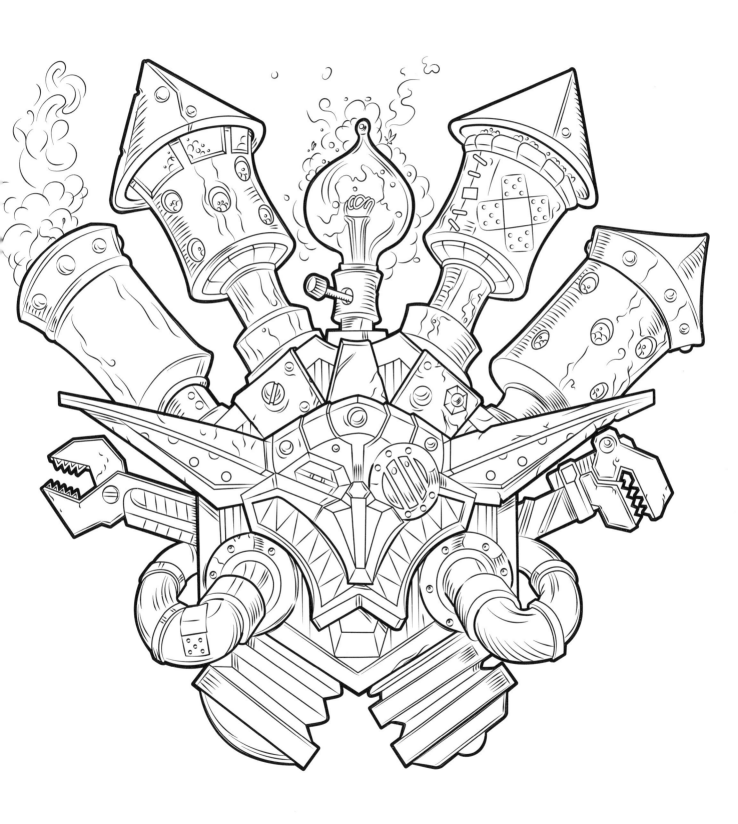

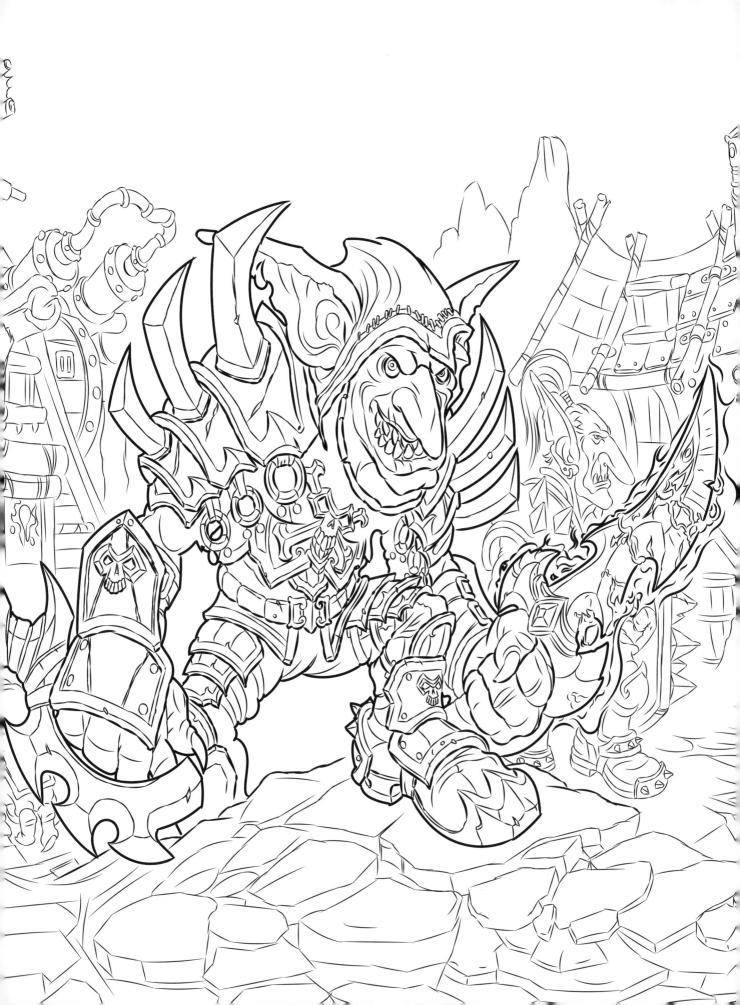

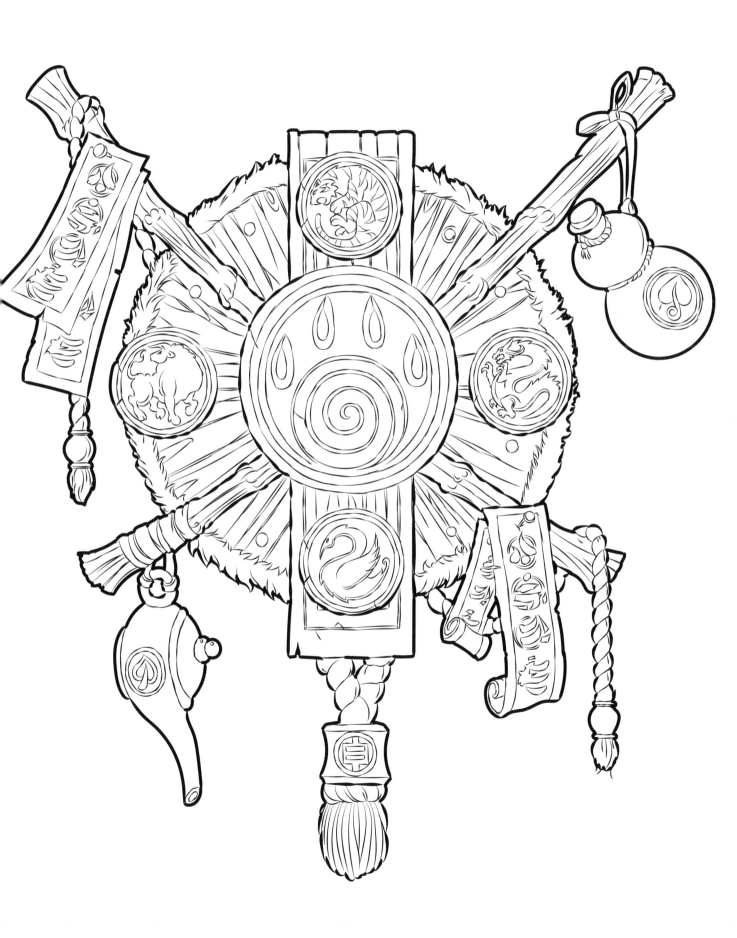

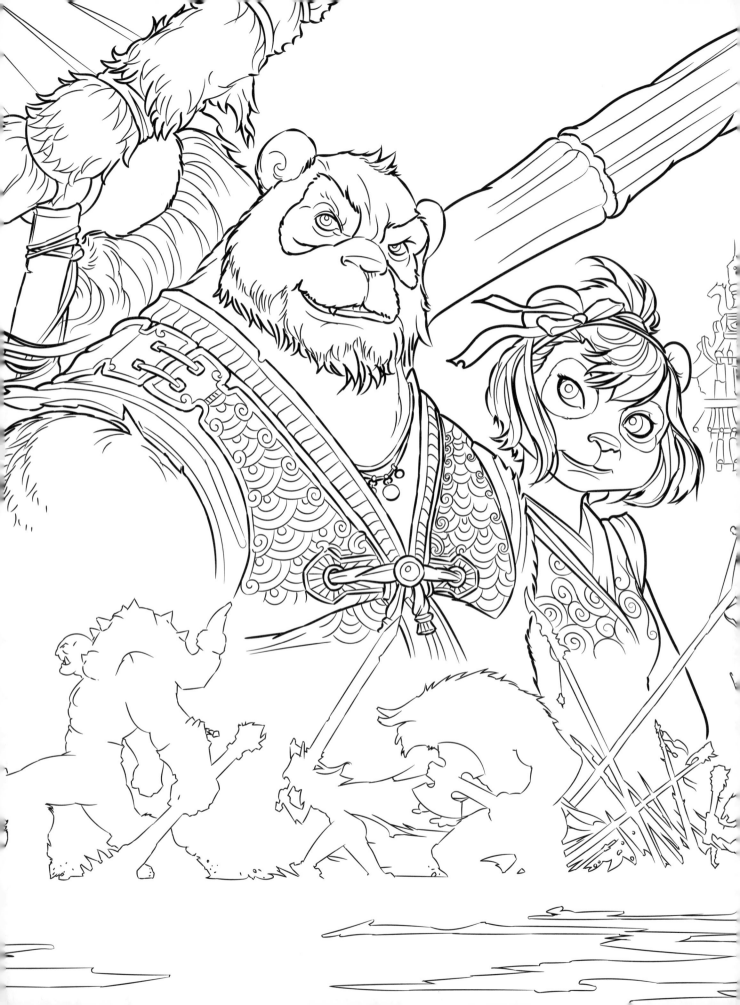

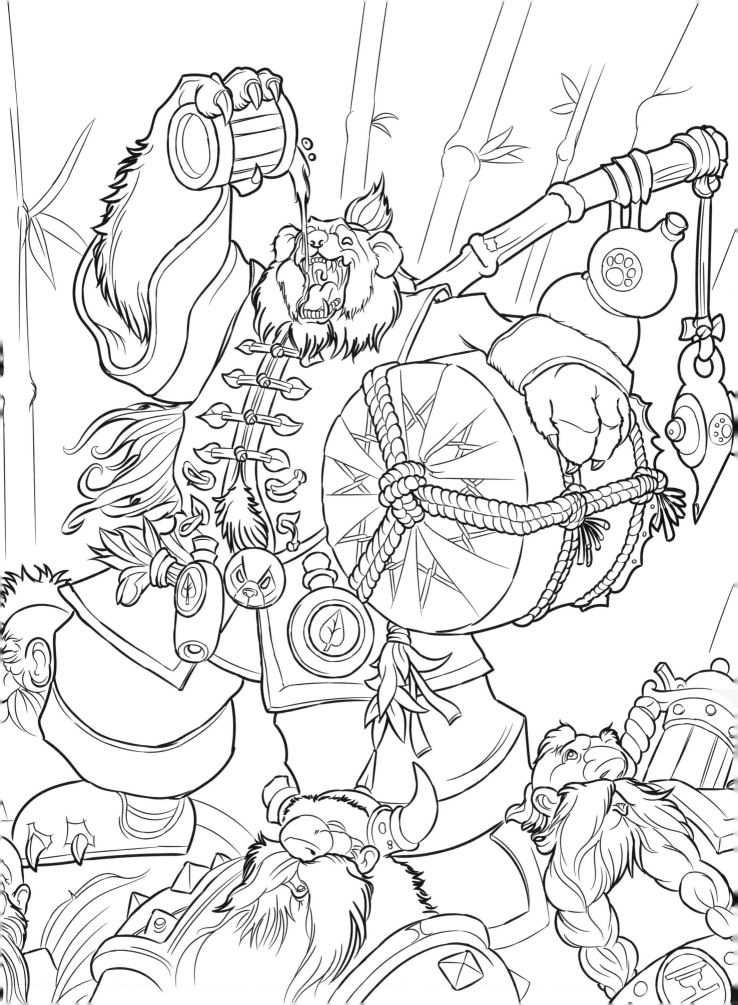

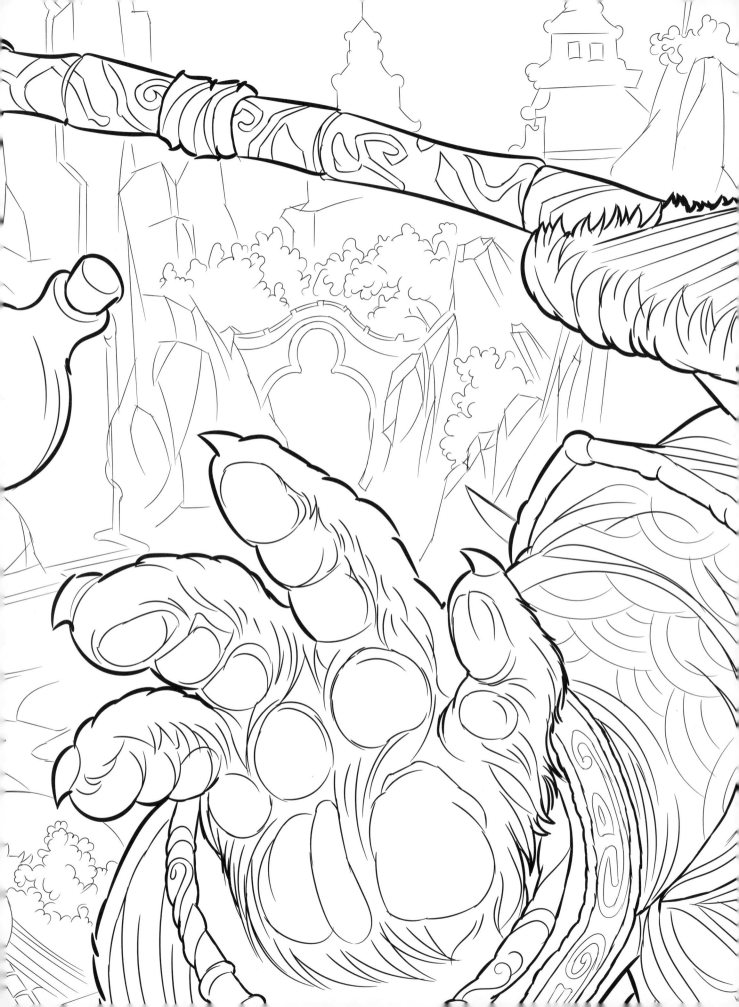

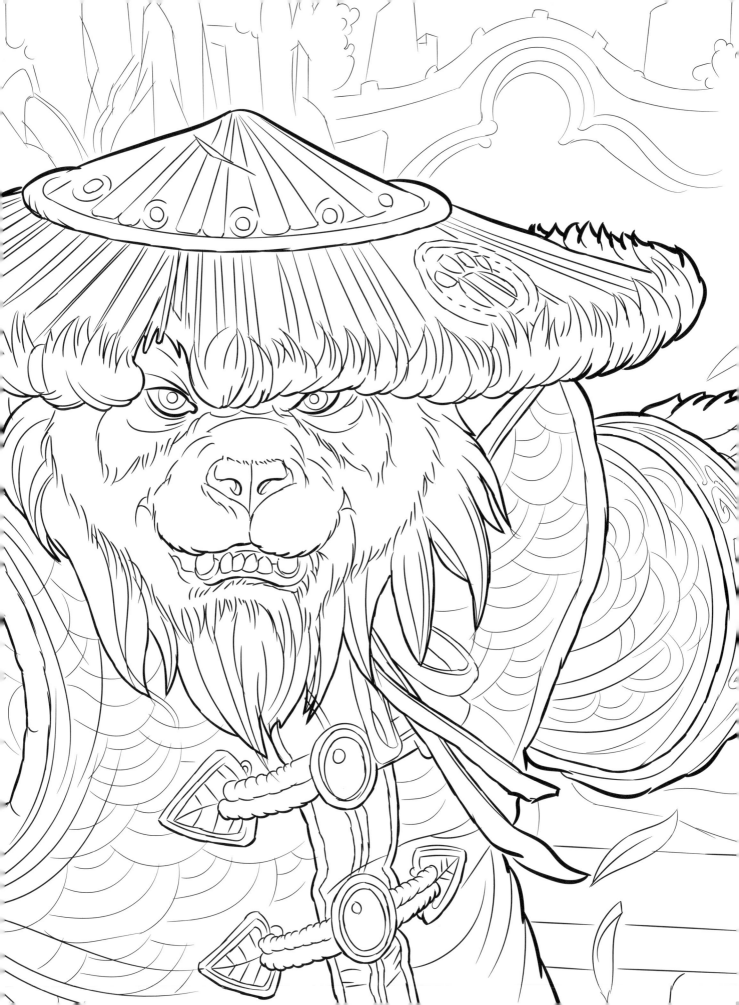

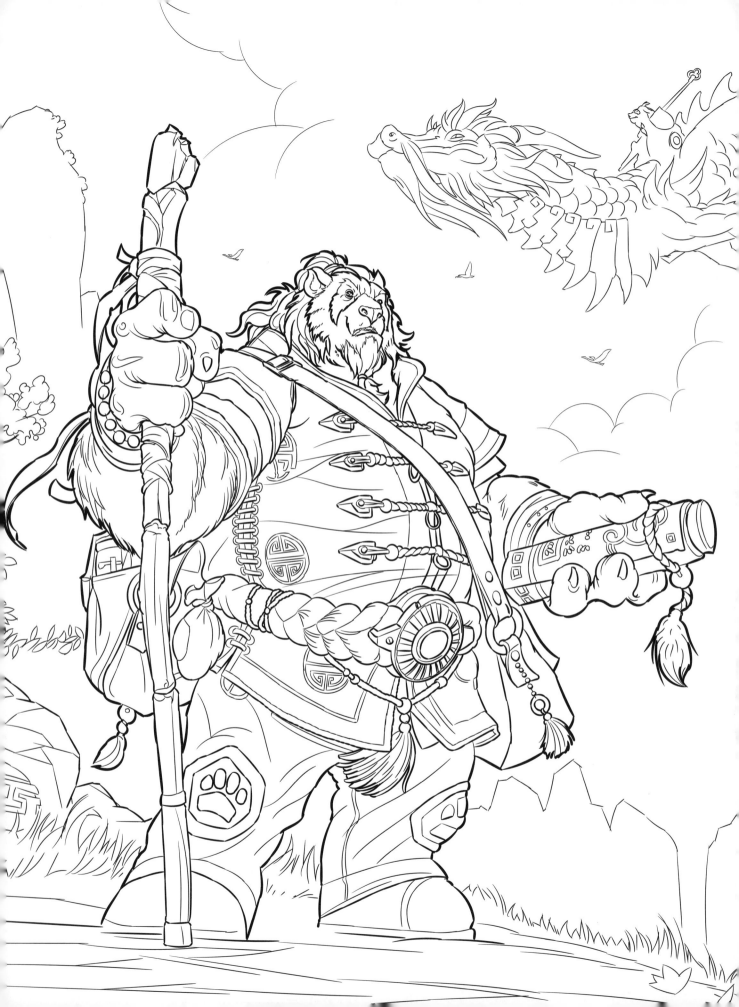

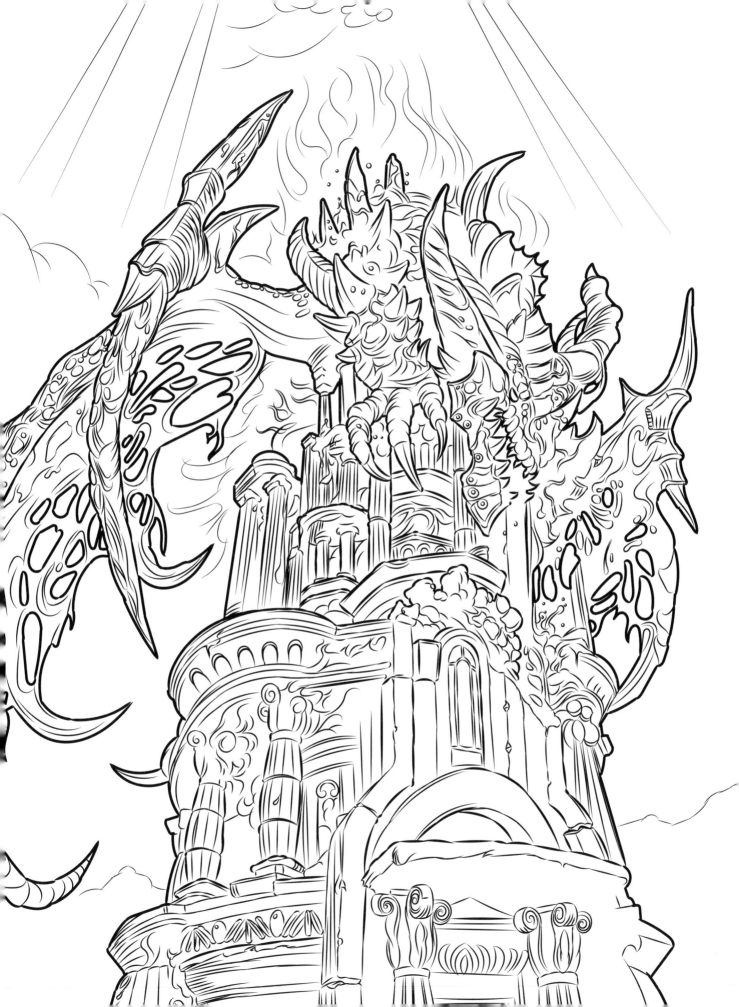

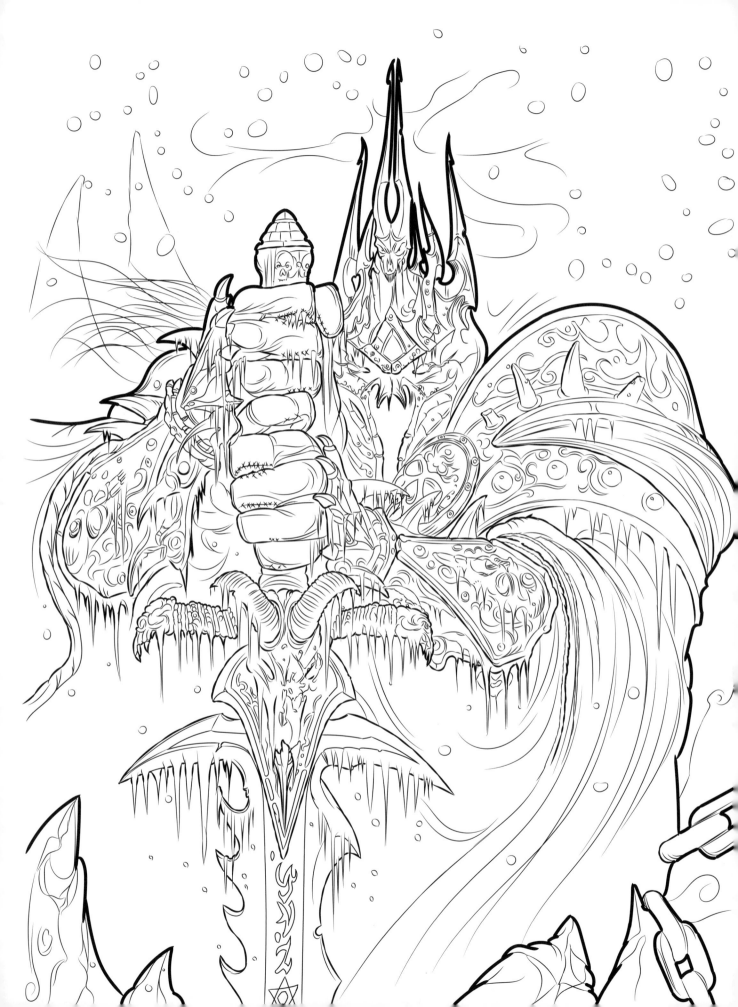

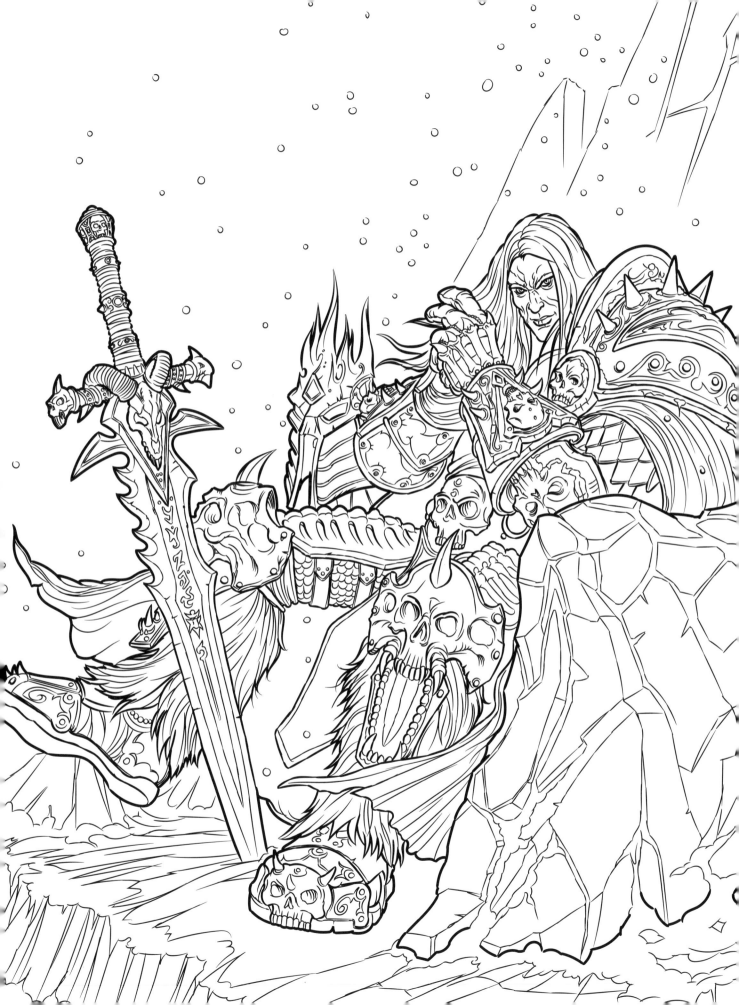

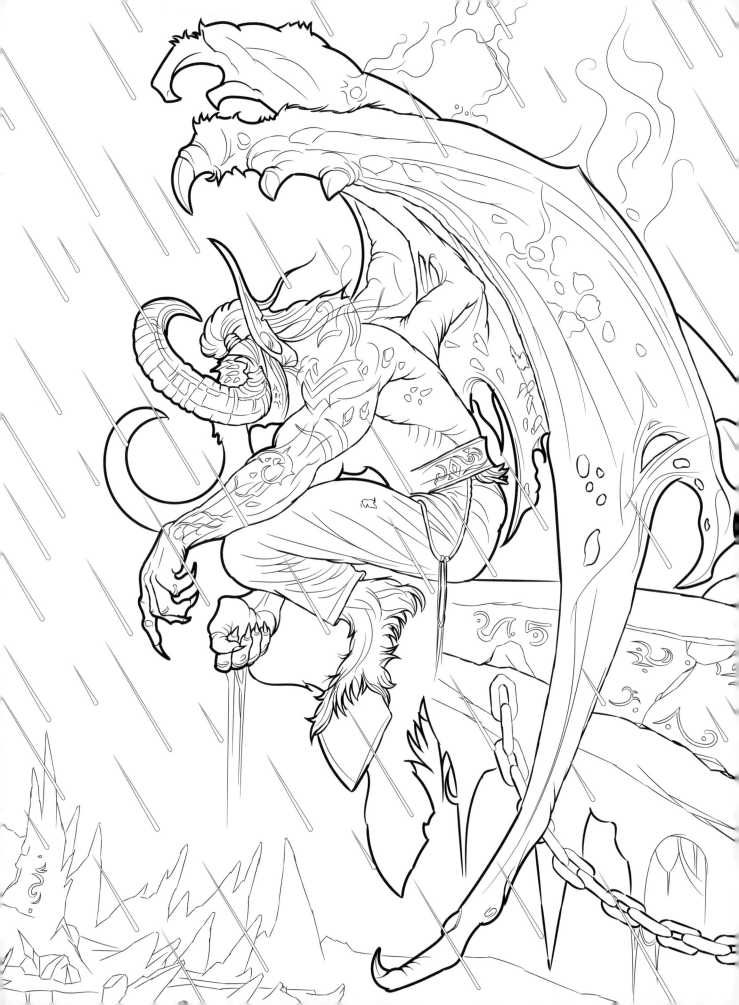

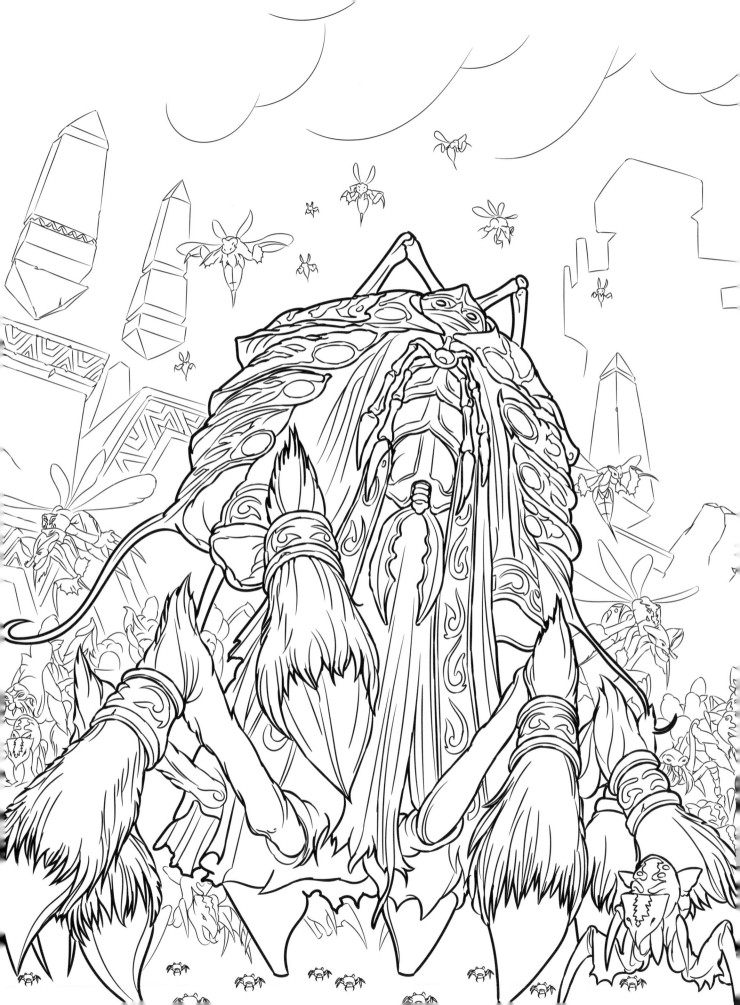

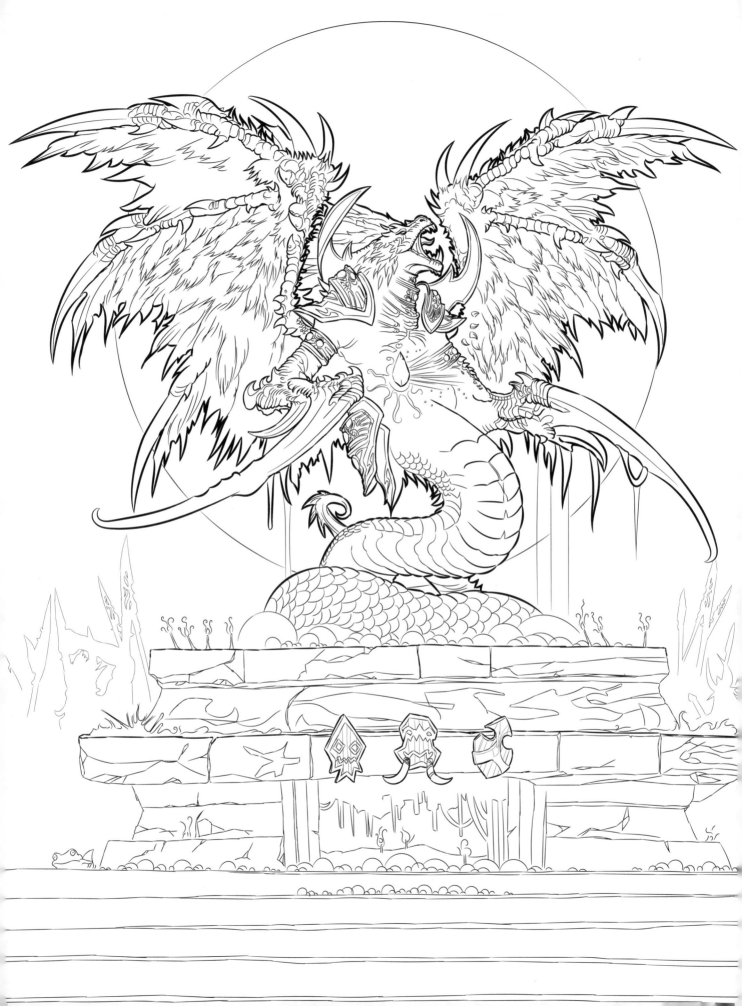

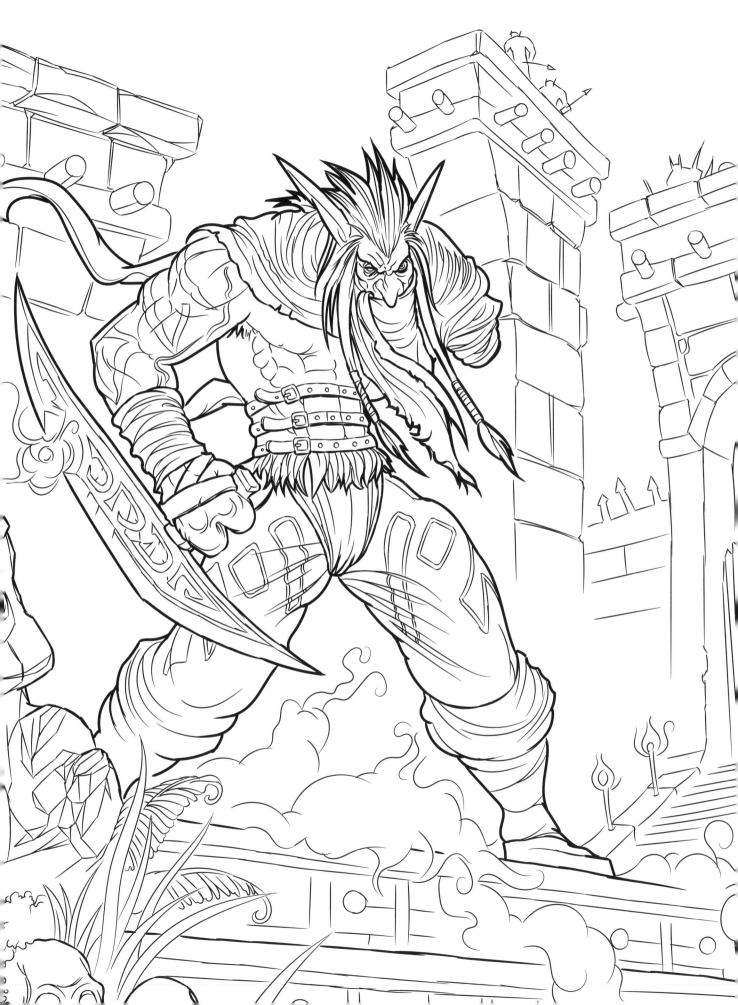

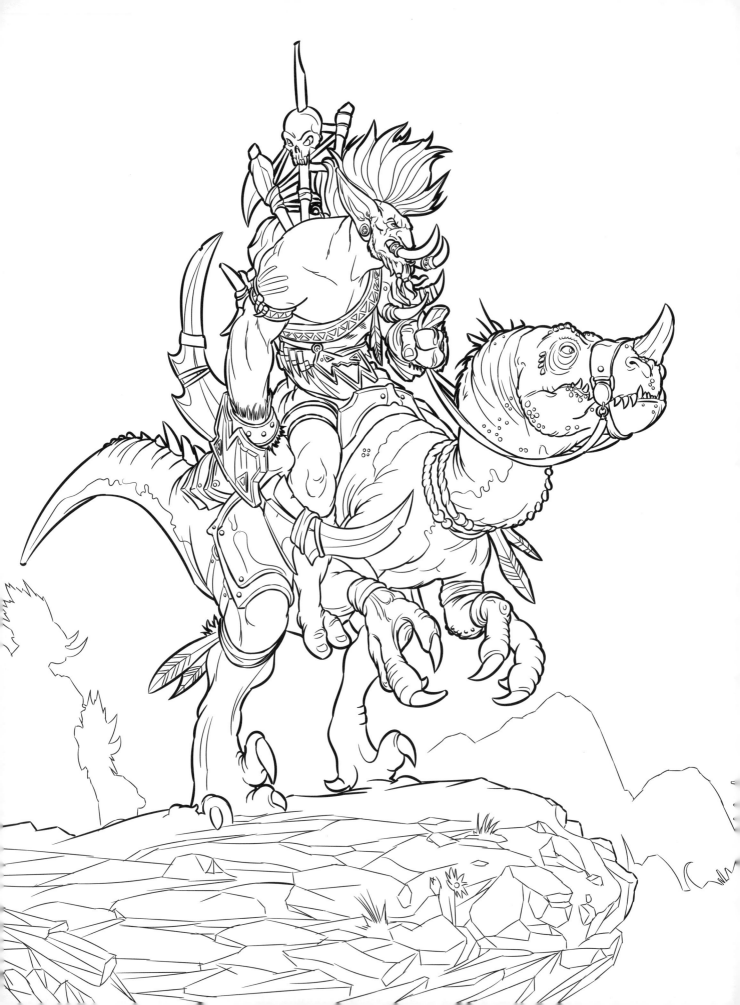

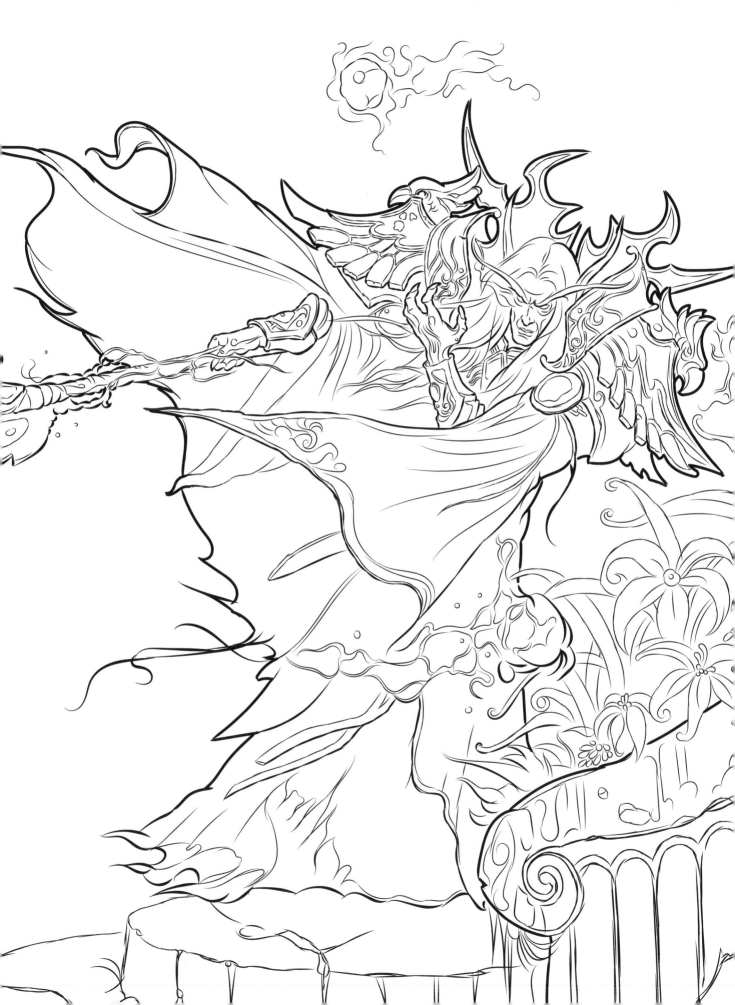

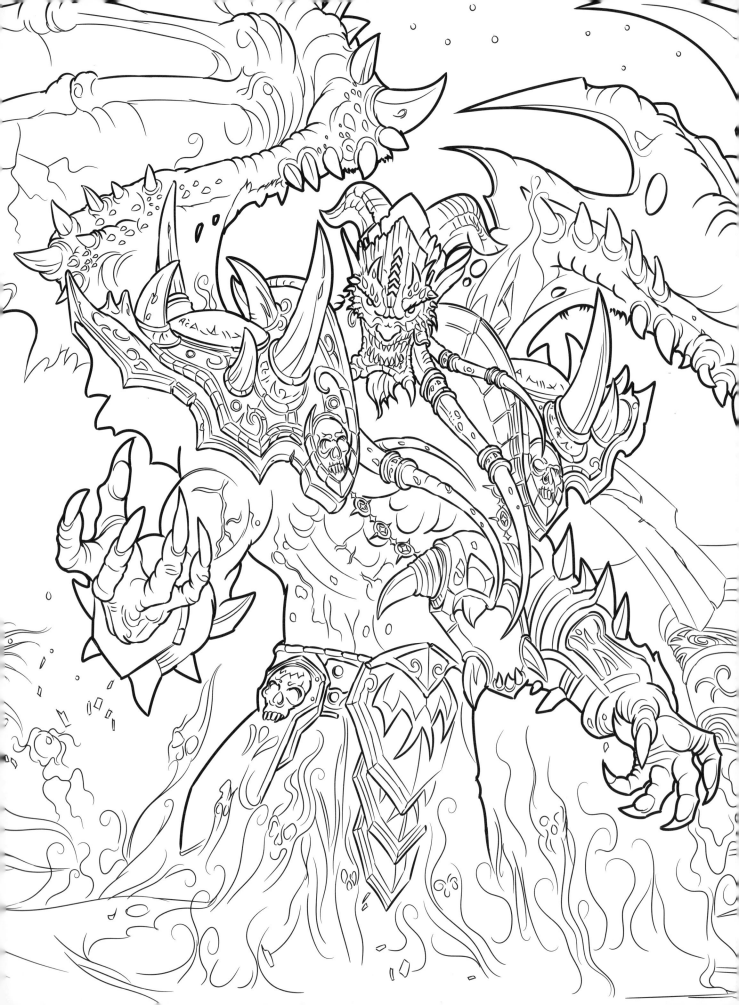

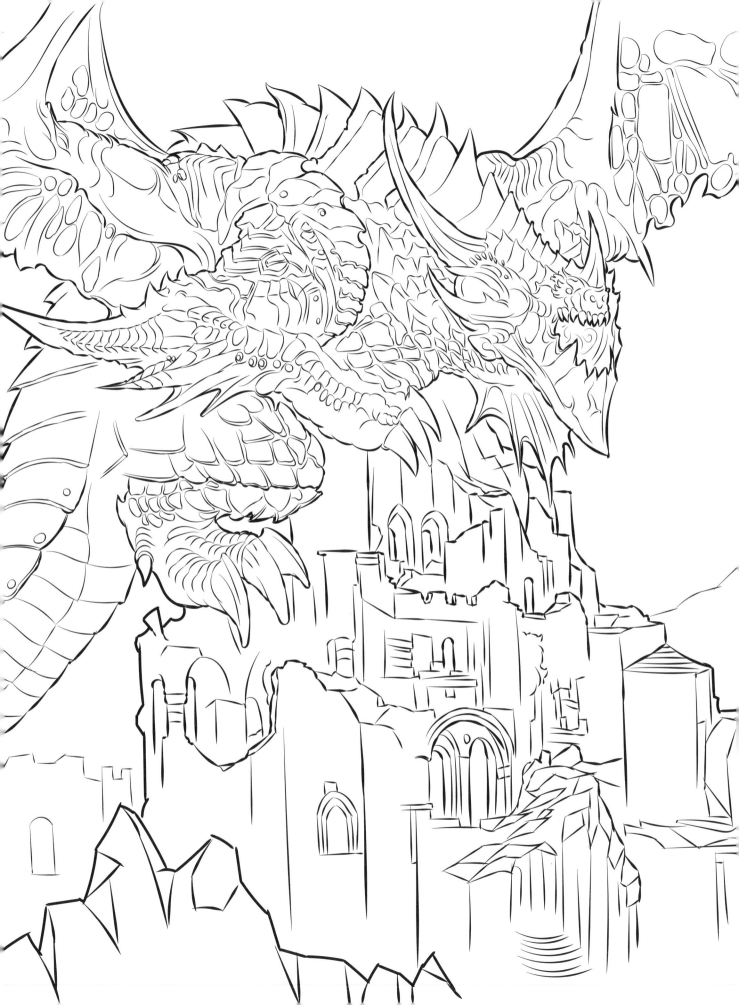

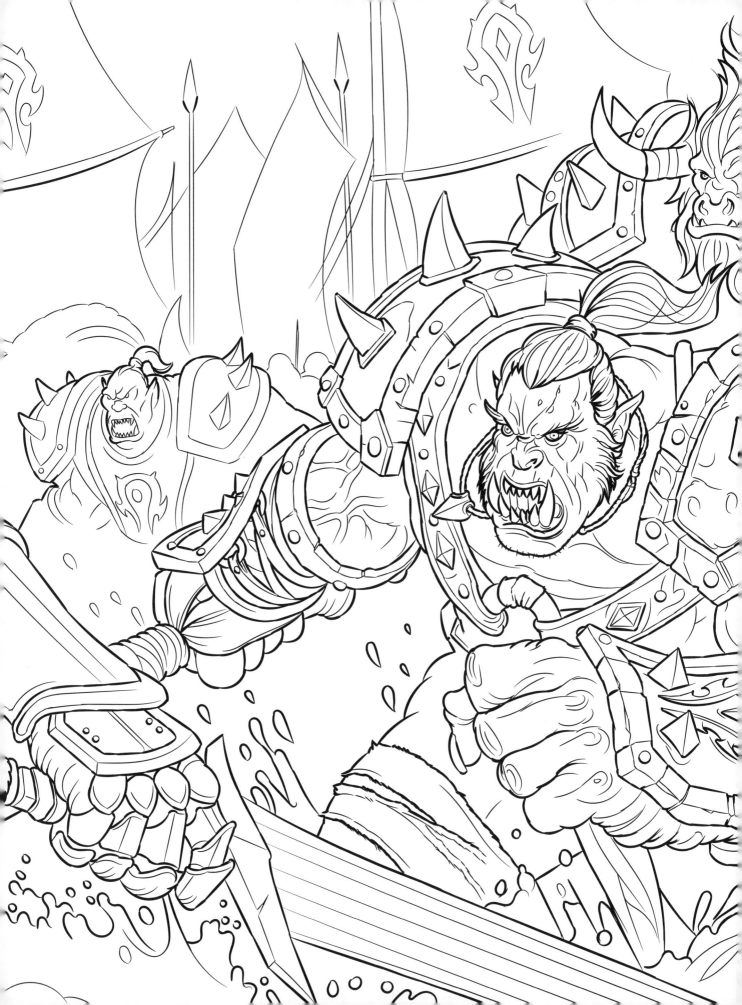

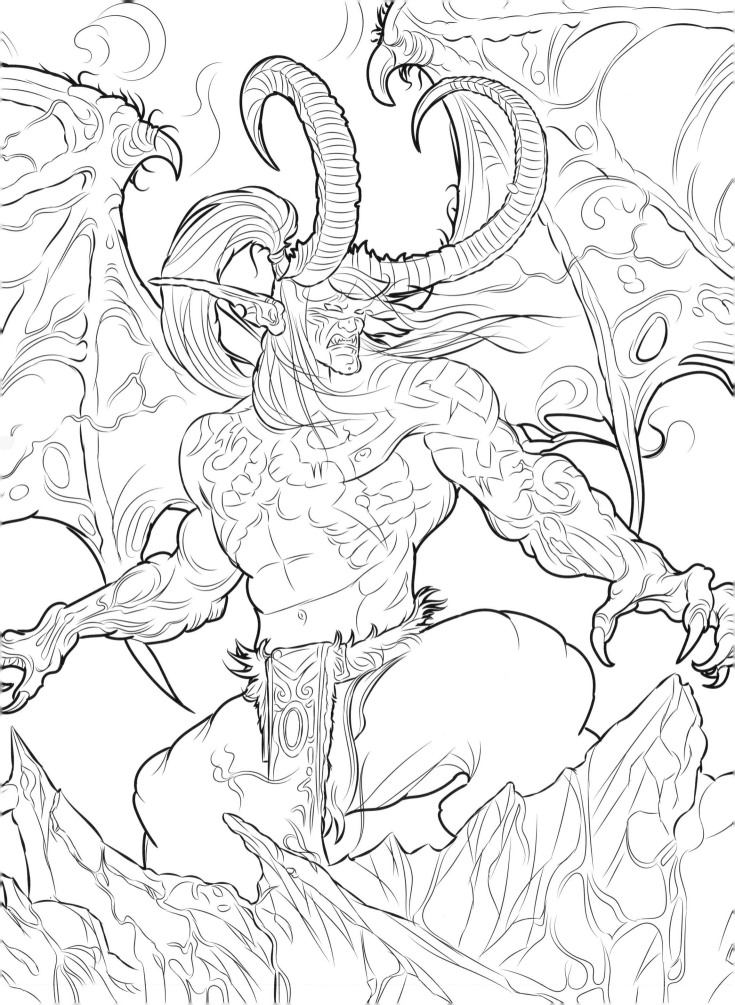

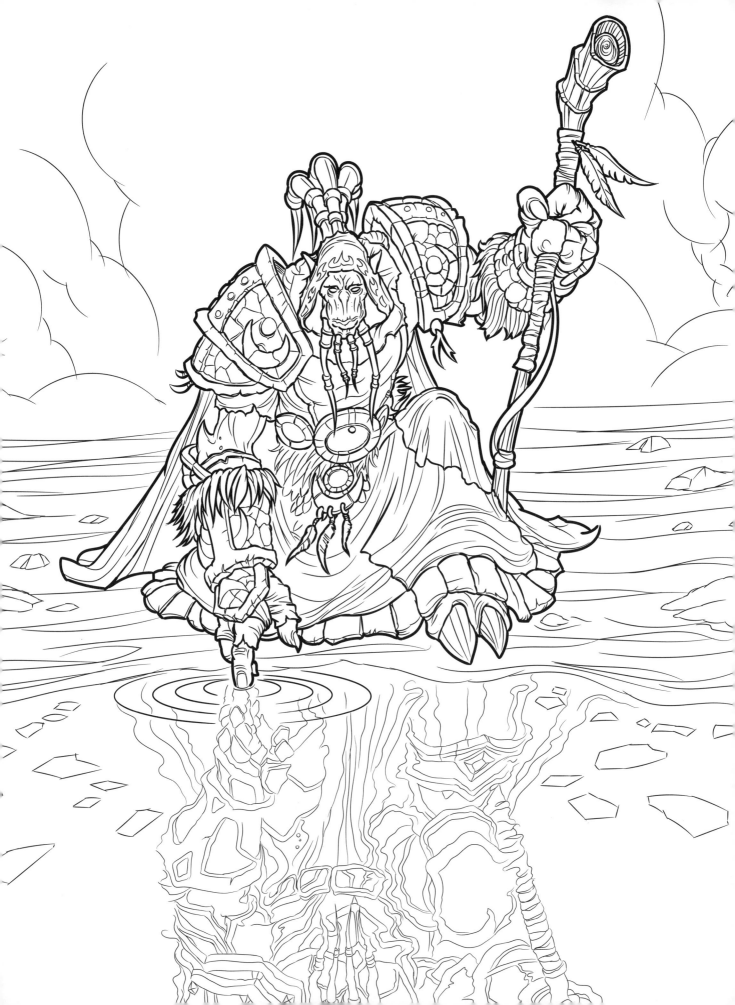

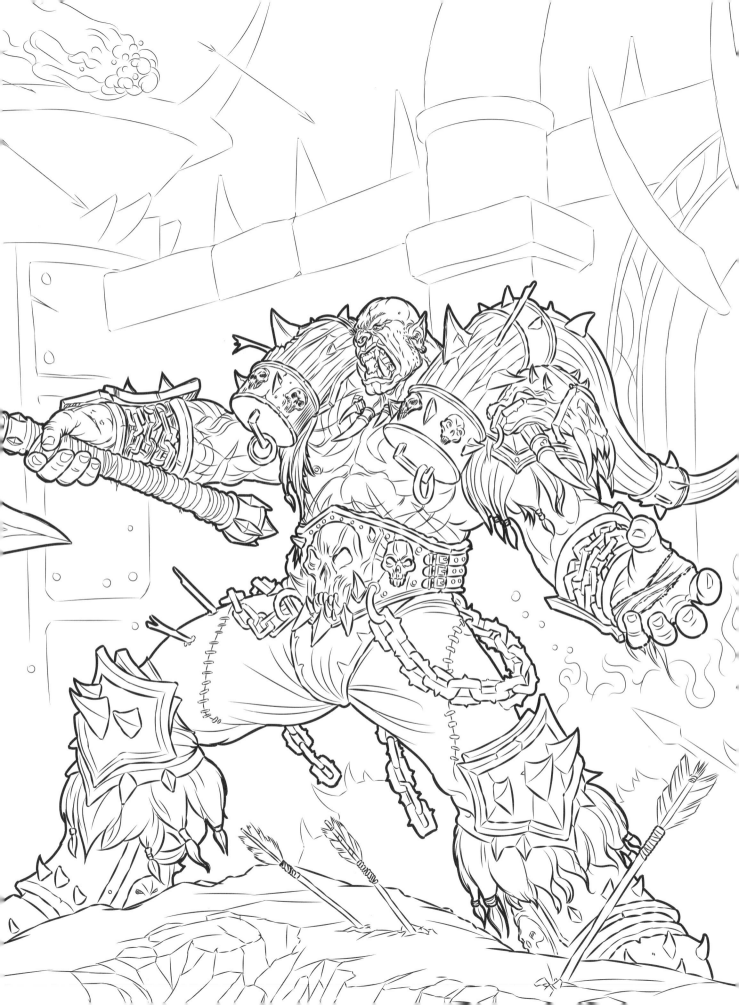

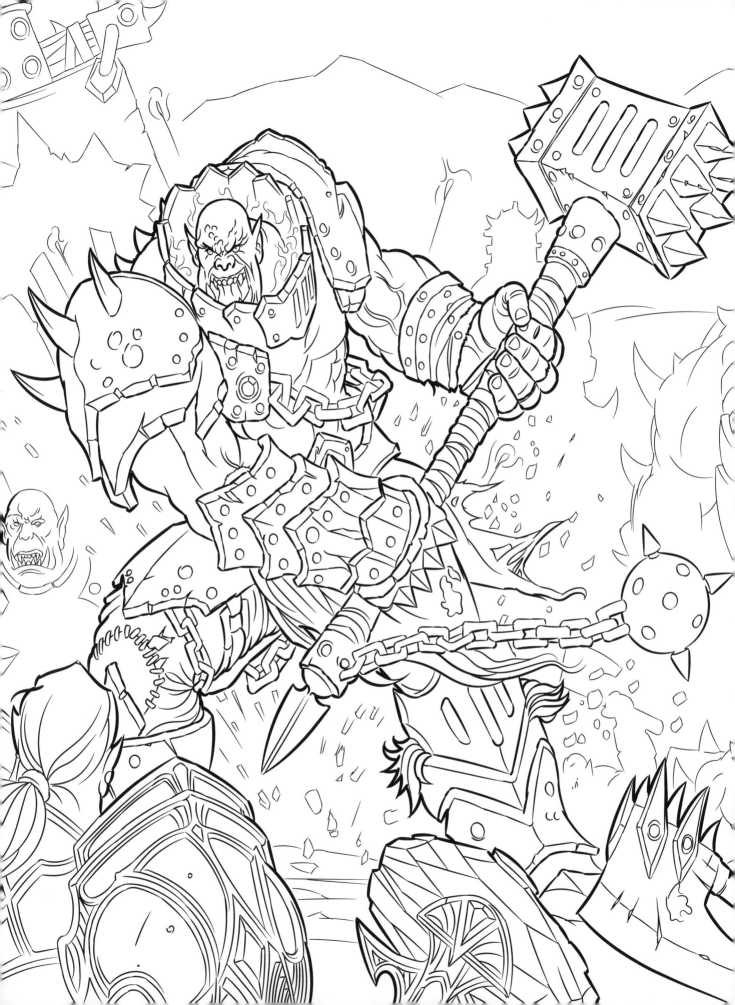

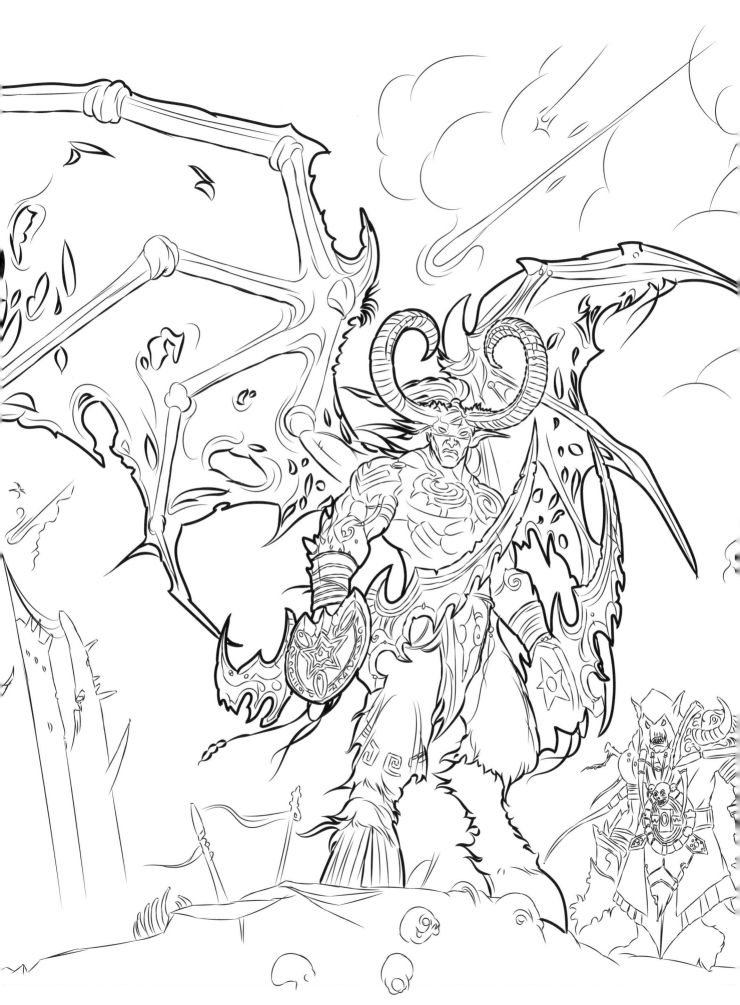

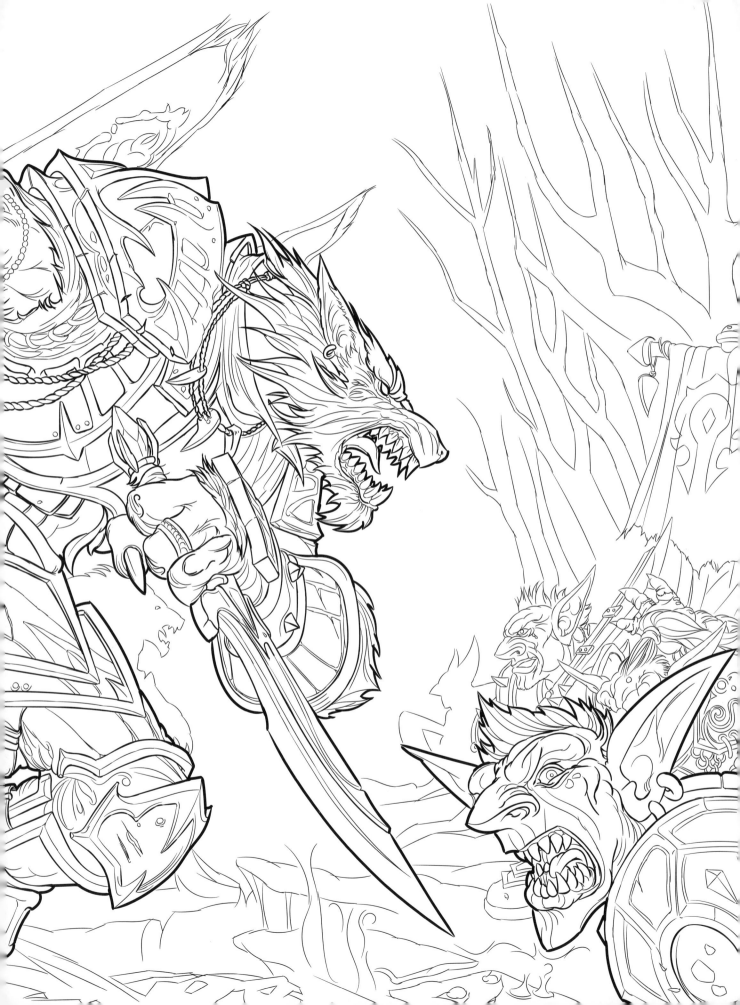

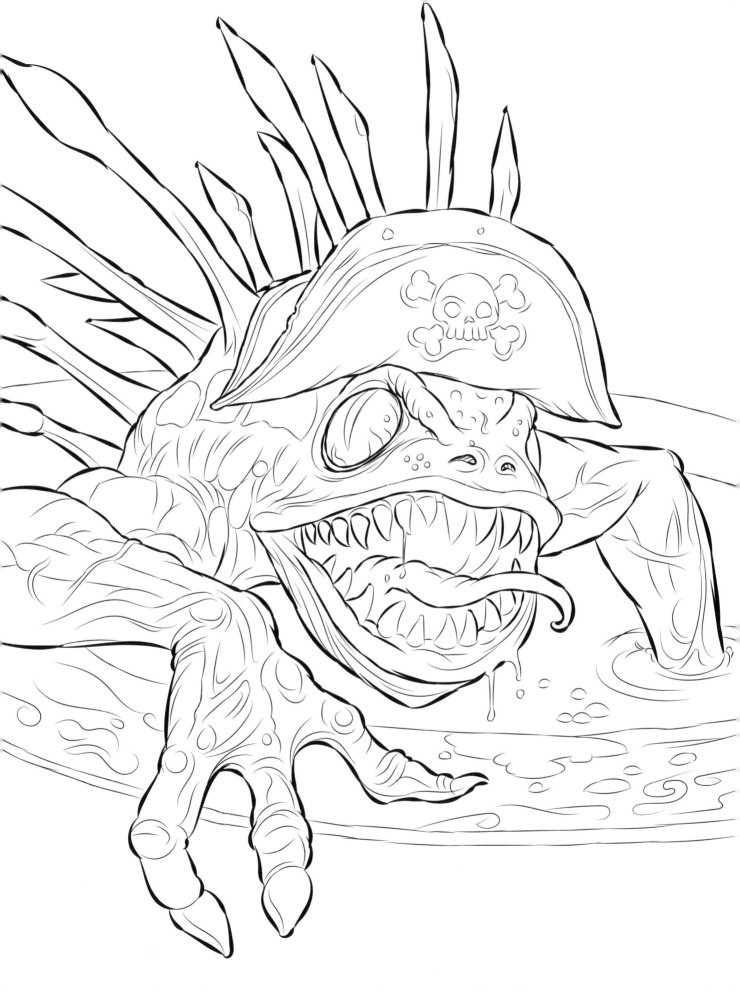

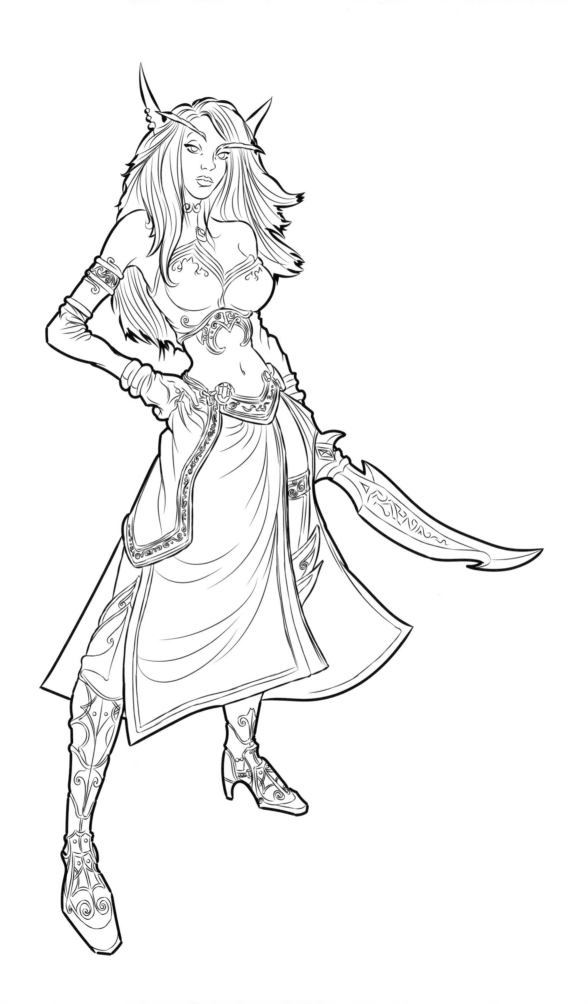

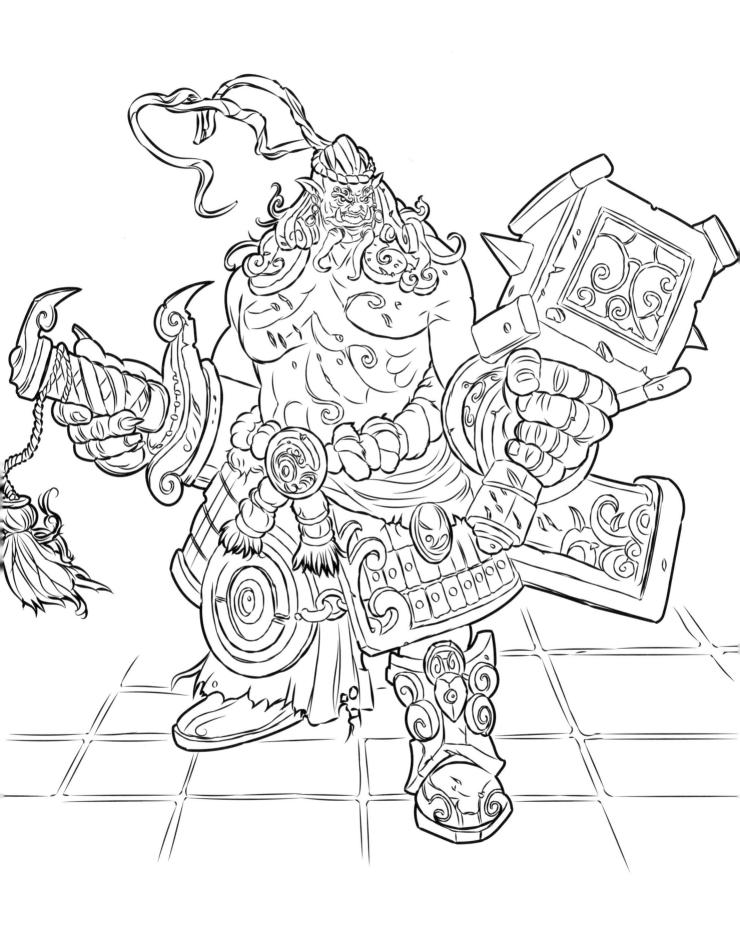

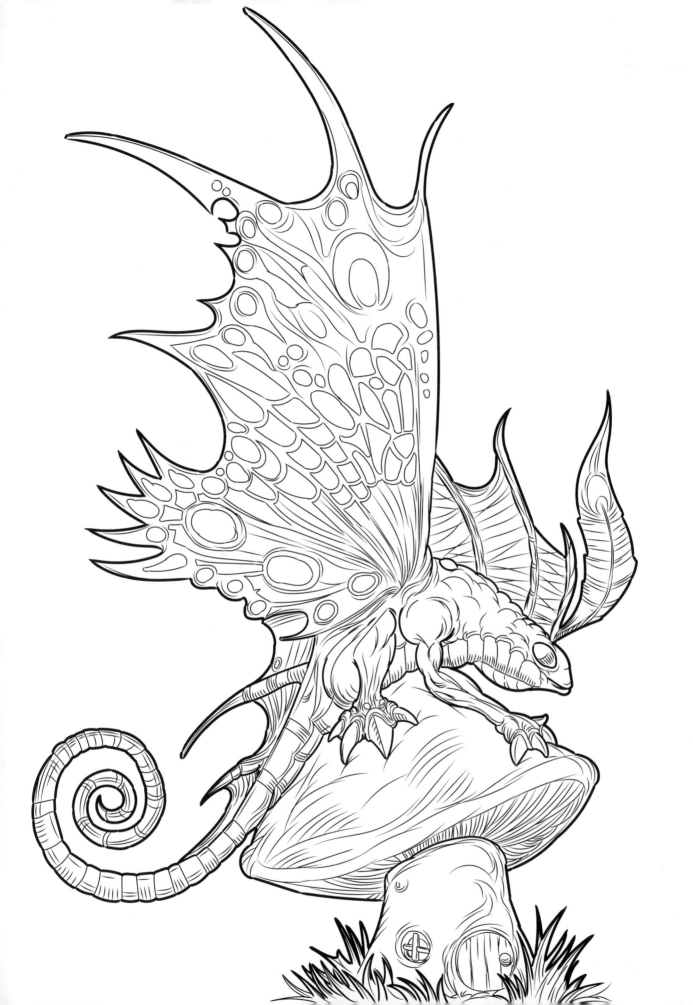